IMAGES
of America

PARADISE VALLEY
ON THE YELLOWSTONE

D1604117

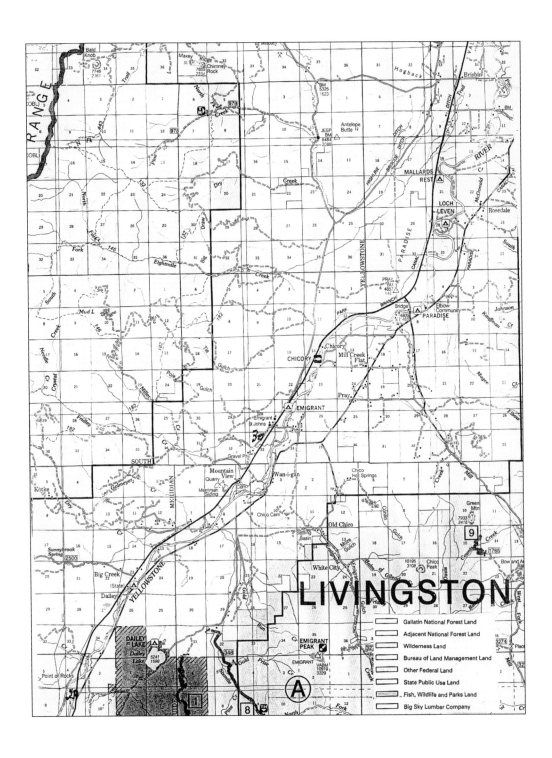

LIVINGSTON

	Gallatin National Forest Land
	Adjacent National Forest Land
	Wilderness Land
	Bureau of Land Management Land
	Other Federal Land
	State Public Use Land
	Fish, Wildlife and Parks Land
	Big Sky Lumber Company

2

IMAGES
of America

PARADISE VALLEY
ON THE YELLOWSTONE

Doris Whithorn

ARCADIA
PUBLISHING

Published by Arcadia Publishing
Charleston SC, Chicago IL, Portsmouth NH, San Francisco CA

Printed in the United States of America

Library of Congress Catalog Card Number: 00-112080

For all general information contact Arcadia Publishing at:
Telephone 843-853-2070
Fax 843-853-0044
E-Mail sales@arcadiapublishing.com
For customer service and orders:
Toll-Free 1-888-313-2665

Visit us on the Internet at www.arcadiapublishing.com

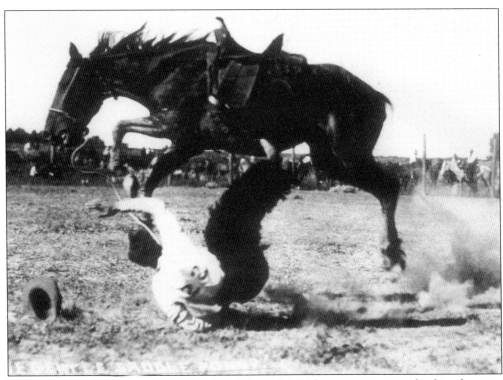

Rodeos are now held in Livingston on July 2, 3, and 4. Riders must stay on a bucking horse at least 8 seconds to qualify for a score. Reserved seats are in the grandstand at the fair grounds. Bleachers require no reservations and are uncovered.

CONTENTS

Introduction 7

1. Gardiner and the Ghosts Downstream 9
 Mile Marker 1 through 9

2. Yankee Jim Canyon and the Wild River 37
 Mile Marker 10 through 18

3. Upper Paradise Valley 49
 Mile Marker 19 through 27

4. Businesses of Paradise Valley 63
 Mile Marker 18 through 36

5. Prominent Creeks of Paradise Valley 93
 Mile Marker 37 through 45

6. The End of Paradise Valley 109
 Mile Marker 46 through 54

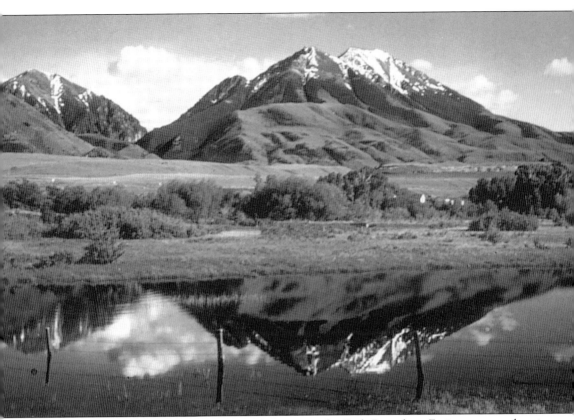

The cover photo of the Northern Pacific train on the Park Branch at Emigrant was taken in the early 1920s, according to NP Historian Warren McGee. The No. 105 would indicate it was a freight engine used for the mixed train service at that time. Chico Hot Springs offered auto transportation for their patrons from Emigrant to their hotel 4 miles away.

I had wanted to use my Emigrant Mountain reflection (pictured above) as a cover photo for this book, but the format was not right. As it wrapped over the spine of the book, it did not show the beautiful reflection produced by the high water and Ruth Jones' plugged-up culvert on June 14, 1956. I had to climb on top of the car to get this view. Emigrant Peak is truly the real focal point of Paradise Valley's beauty.

INTRODUCTION

The photographs in this book are my gatherings during the 52 years I have lived on the Yellowstone River in Montana. Half of that time was spent in a small roadside business on the very banks of the river. This business, Wan-I-Gan, was a complete service stop midway between Gardiner and Livingston, Montana. A passerby could buy gas, fishing gear, groceries, beer, a meal, or lodging. If the desired item was not available for purchase, it was loaned from the family's possessions.

Yes, these are my "gatherings," but they are the products of my husband Bill's photographic work. In the early 1950s, customers began asking Bill if he would try to reproduce some old, treasured family pictures. He tried, and became quite an expert at it.

I had to find out what the photos were all about. So the Bill-Doris team started on specific historical subjects. We were prodded by Fred Martin, editor of *The Park County News* in Livingston, who for six years depended on us for his annual *Pioneer Edition*. As payment Martin printed several hundred small, 48-page *Photo History* books for us to sell. Thus developed the self-publishing of historical volumes with photos borrowed from our customers and information gathered from them.

Besides reproducing old photos, Bill and I have always carried cameras. The result is a massive collection of prints and slides of the area where we lived and the places we traveled.

Bill continued his darkroom work until his death in 1990. I have continued historical research and self-publication. In addition, I have been given some collections. Sometimes these find family homes through me.

Local booksellers have told me they would like to have a book such as this on Paradise Valley. Our very first title was *60 Miles of Photo History*. It covered the 60 miles from Livingston to Mammoth in Yellowstone Park. Since it has been out of print for 30 years, I thought the idea was ripe for production.

Since there are now paved roads on both sides of the Yellowstone River and good mile markers on Highway 89, I wanted to locate photos by them. The six chapters of this book are 9-mile segments of highway. A "MM 8.5E" would mean halfway between Mile Markers 8 and 9. The letter would mean that the location is on the east side of the Yellowstone River, whether or not this was the Highway 89 side.

You see, this is meant to be an abbreviated historical guide that includes Paradise Valley. If you want a detailed map, stop at the Forest Service Office in either Gardiner or Livingston. Ask for the *Gallatin National Forest, East Half*. The cost is $4.

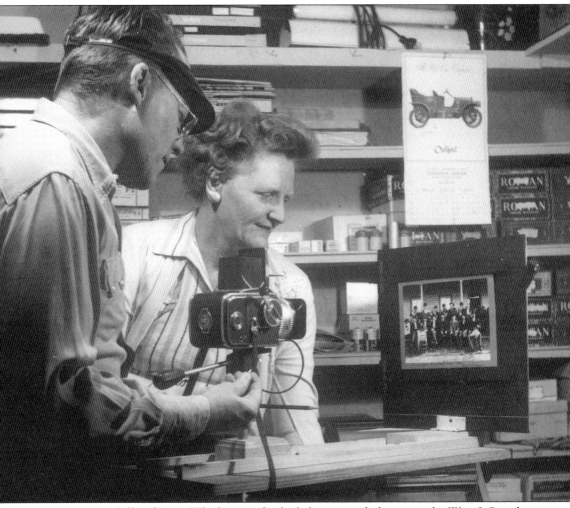

Here we are, Bill and Doris Whithorn, in his little basement darkroom at the Wan-I-Gan short-
ly after he got his Hasselblad. You know, I suppose that the Hasselblad was the camera that the
astronauts took to the moon.

One

GARDINER AND THE
GHOSTS DOWNSTREAM
MILE MARKER 1 THROUGH 9

Gardiner is not really a part of Paradise Valley, but the Yellowstone River goes through as it flows down north through the valley. Gardiner (with a population of about eight hundred) is second in size to Livingston in Park County, Montana. Park Street, which many Gardiner businesses face, is in Yellowstone National Park. The town is one of the park's bedroom communities. It was the first entrance into Yellowstone and the first one to have a railroad connection.

Gardiner's proximity to Yellowstone gives it a particular interest in the animal population there. In winter, animals seeking lower elevation and less snow than that which accumulates in Yellowstone give Gardiner businesses a shot in the arm during Montana's big game hunting season. Gardiner is sometimes spoken of as being in the "Banana Belt," because at an altitude of 5,200 feet, it has relatively mild winters. We shall start our historical tour with long-gone sights around the town. Mile Marker 1 starts on Park Street.

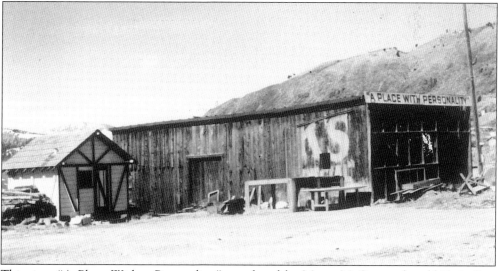

This sign, "A Place With a Personality," was found by Marge McCoy at the old Twin Bar. Mounted on this old building near her home, it evoked many comments. Leeson's 1885 *History of Montana* listed Gardiner's population as two hundred, with 21 saloons, 6 restaurants, 5 general stores, 2 barber shops, 2 dance halls, and 4 houses of ill fame. Since there was no sawmill, only tent houses existed, along with a few log shacks.

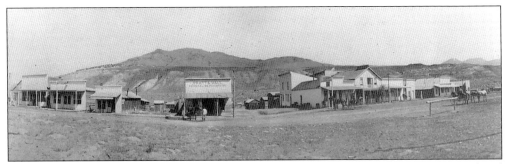

This picture of Gardiner hung in Otho Mack's barbershop for many years. In late 1897, Colonel Franklin Pratt came to the town. Before he went mining in the Crevasse area, he became a merchant with W.A. Hall. In front of the store is the water cart from which a Chinese man sold water for 50¢ a barrel.

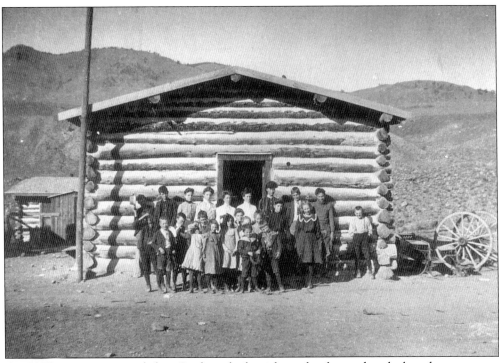

An 1885 account reported that Gardiner had neither school nor church, but that was soon remedied by construction of this log building. A one-story schoolhouse was built of native rock in 1904. A second story was added in 1910, when money was available.

Children from the north side of Gardiner attended school by crossing on this swinging footbridge. Business people and property owners contributed funds to build it. It served from 1914 until April of 1930.

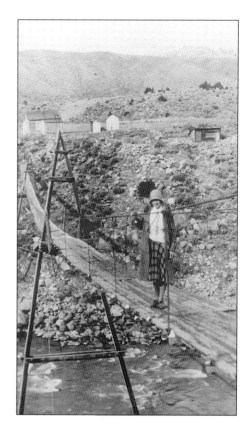

President Theodore Roosevelt spent April 8 through April 24 of 1903 in Yellowstone Park. During that time, he had been asked to participate in the ceremonies dedicating the arch at Gardiner. Major John Pitcher, Commandant of the Park and fellow charter member of the Boone and Crockett Club, had been in Washington D.C. in February and invited the President to stop in Yellowstone on his planned West Coast tour.

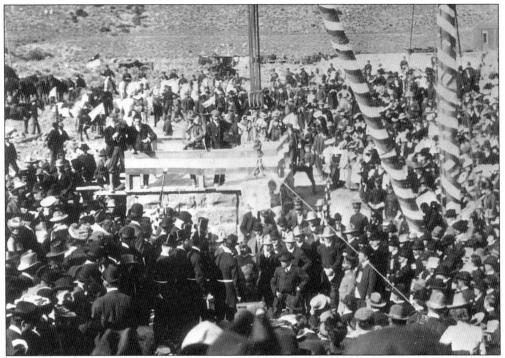

Gardiner became alive with the 3,500 people who attended the ceremonies when President Roosevelt spoke. In this photo, the cornerstone hangs ready to be lowered on the cement which Roosevelt will spread. Masons were in charge of the laying of the cornerstone.

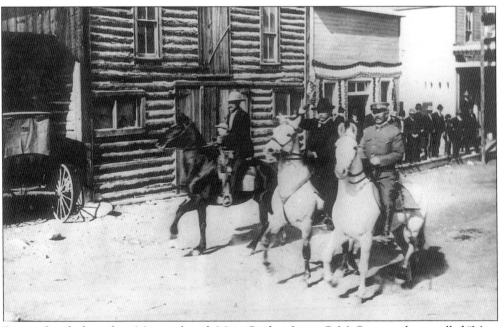

Roosevelt rode down from Mammoth with Major Pitcher. James C. McCartney, the so-called "Mayor of Gardiner," joined them. The child is thought to be Paul Hoppe, son of Walter Hoppe, owner of the log livery stable in the background. Upstairs from the stable was a public dance hall.

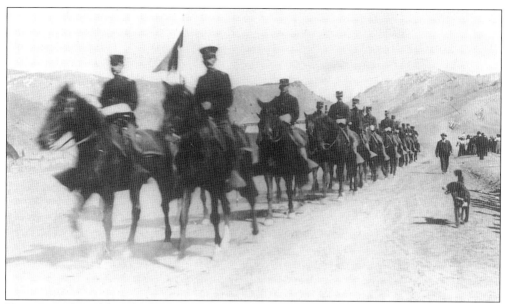

Troops B and C of the Third Cavalry came into town at a fast trot. "The president walked swiftly with eyes 40 feet to the front as though he were marching in a parade with his regiment," said one reporter. Where else but in Gardiner would the President of the United States be led by a stray dog?

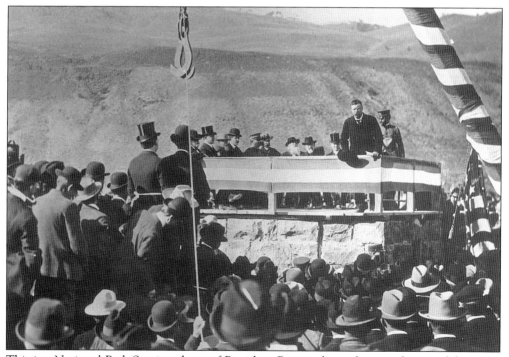

This is a National Park Service photo of President Roosevelt speaking to the crowd from one pillar of the arch built to 8 feet in height. Among others on the platform were Wm. Loeb Jr. (Secretary to the President), Captain Chittenden, Major Pitcher, Cornelius Hedges (credited with first presenting the idea of a national park), and John Burroughs (Roosevelt's bearded traveling companion).

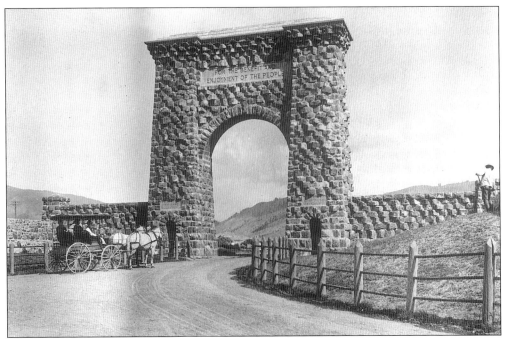

Roosevelt never saw the completed arch, but the cornerstone is there for all to see on the Yellowstone National Park side of the right pillar. By mid-August of 1903, some carriages were admitted through the arch, even though it was not totally completed.

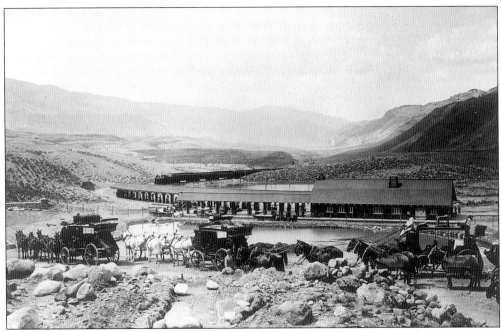

While the arch was under construction, the Northern Pacific Railroad Co. was building a beautiful passenger depot nearby. From the depot, 32-passenger "Tally-hos" carried visitors to Mammoth in Yellowstone Park. A new depot replaced this one in 1956. There has been no regular passenger service to Gardiner since September 3, 1948.

14

The pond between the arch and the depot was divided into two parts to portray the monad—trademark of the Northern Pacific Railroad. A Bozeman paper suggested that it should have gold fish in one side, and white fish in the other. This is now the Arch Park.

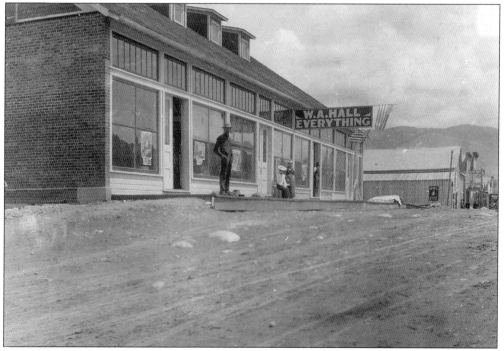

Moving in from Cinnabar in 1903, W.A. Hall built a big store where groceries, dry goods, furniture, farm machinery, and just about everything else was available. Hall continued in business until 1955. It is now Hi Country Book & Souvenir Shop, with a coin laundry in one end.

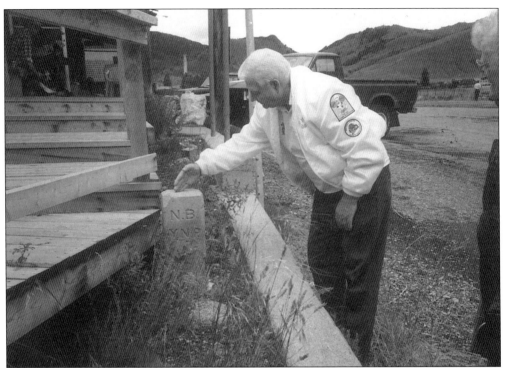

In this 1992 photograph, Bill Hall of Napa, California, examines the "North Boundary, Yellowstone Park" concrete marker which still stands near his grandfather's old store building.

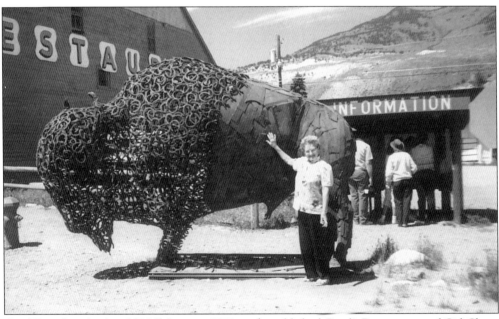

Cecil Paris bought the old Hall Store in 1961, and established Cecil's Restaurant and Gift Shop. In 1972, Ken Dixon became the manager there for a corporation that took over the establishment. Here is the east end of that building on June 29, 1987, with the metal sculpture that was there a couple of years. My friend Bobbi Sackett of Emigrant demonstrates its size.

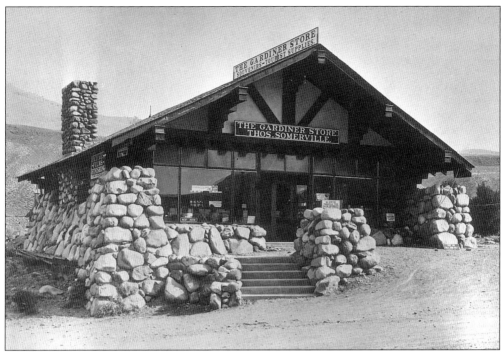

Under threat of being barred from Yellowstone Park, Harry Childs—czar of the transportation company—would park his Franklin here and be met by horse conveyance until cars were allowed in the park after August 8, 1915. Haynes bought the building, and Mrs. Tom Somerville operated it for three years in the early 1920s. Siblings, yes, but some Sommervilles used one "m" and some used two.

Freighter Charlie Scott lived in a rock house. He hauled the rock for the arch. With him are his mother, Lillian Bigelow; Kirby Lott; and Scott's wife, who was Addie Bigelow before her marriage. In April of 1904, the paper reported that work had begun on Scott's new rock house. Just before this, Larry Link had built the first one.

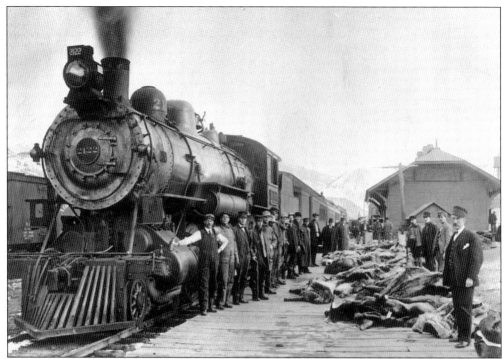

When word that "the elk are out" went abroad, the passenger trains arriving in Gardiner looked like an arsenal, and the freights leaving looked as if they were packing-house-bound. Here at the freight depot on Spring Street in 1911 are Jim "One-eyed" Parker, whose wife ran the Cottage Hotel (on the left), and Shoemaker Emil Meyers. Conductor J.J. Clark is at right.

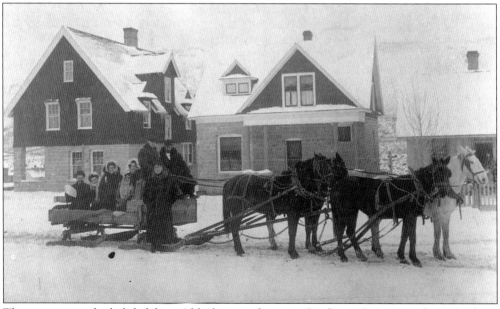

This group came by bobsled from Aldridge to a dance in Gardiner. Going to a dance in those days was a 24-hour affair, as the trip was 7 miles and at a 3,000-foot lower elevation. Note the man clowning with a fan. Rock houses can be seen in the background.

In 1910, the Eagles Lodge built a hall with a dance floor, stage, kitchen, and dining room. The basement even served as a high school for 15 years. Eagles shown here in 1913 are, from left to right, as follows: (front row) Charles Huntley, Lawrence Link, Dan Tripp, Harry Lloyd, Nig Tyter, Billie Salee, Frank Leland, Wm. Menefee, Henry Pilger, and W.S. Berry; (second row) George Hoffman, Frank Holem, Boyd McGee, Zeke Dean, Harley Reaves, Gus Graff, Earl Willard, Frank Lind, Al Collins, Dave Hauptman, Jack McPherson, Jake Darmstadt, Jim Brown, and Robert Sommerville; (third row) Dick McBride, Horace LaBree, Frank Dean, unknown, Wm. O'Laughlin, Roy Armstrong, Horace Stebbins, Charles Acklimer, Frank Rife, Bill Ryan, Wally Walker, L.H. Van Dyke, Ernie Petre, George Welcome, John Dewing, and Charles Davis. Jack Herrin and Ed Pierce are in the doorway.

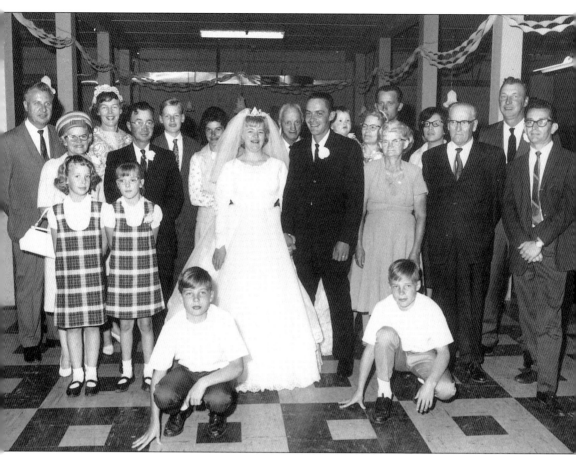

The Eagles Hall was available for wedding parties such as this one, which followed the marriage of Judy Mikolich and Allen Jensen on August 28, 1966. Shown here, from left to right, are as follows: (floor) Andy and Alan Mikolich; (front row) Susan and Cheryl Wright; (second row) Annie Mikolich, Charlie Mikolich, Judy (Mikolich) Jensen, Allen Jensen, Julia Kingsford, Kenneth Kingsford, and Loren Wright; (back row) Rudy Mikolich, Sally Mikolich, Dennis Mikolich, Delores Kopland, Roy Anderson, Lucile Anderson (holding Doyle), Donald Anderson, Rose Anderson, and Frank Kopland.

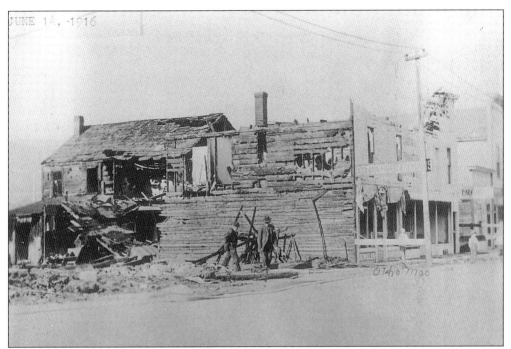

Gardiner has had many disastrous fires. Here are the remains of the old livery stable, which the Moores had converted to a dry goods and souvenir store, when a fire struck in June of 1916. On August 31, 1889, the town was almost totally destroyed when 13 homes and 19 businesses burned.

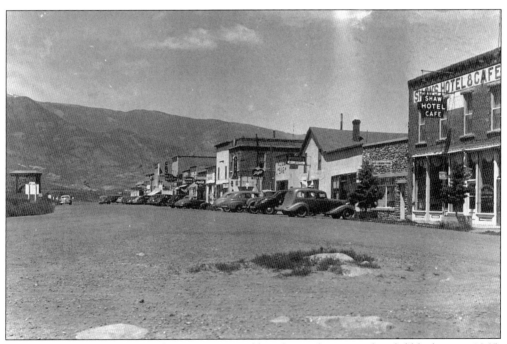

The gravel turnaround on Park Street, centered by a big rock, was made solid blacktop in 1965. The front part of the Shaw Hotel burned in 1950, but the back walls still serve the Town Café. An upstairs dining area has a most unusual sign made of silverware.

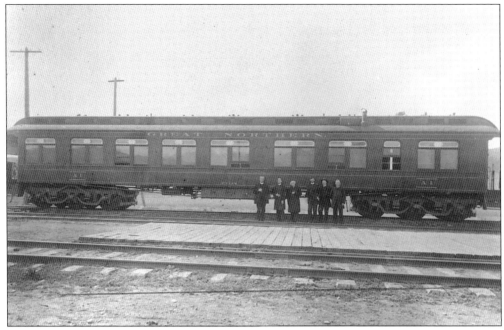

From 1915 into the 1930s, Gardiner Catholics used the Great Northern's famous chapel car for worship. Members of the Civilian Conservation Corps of the 1930s who worked in Yellowstone Park also used it. St. William's Catholic Church was built of native travertine in 1954.

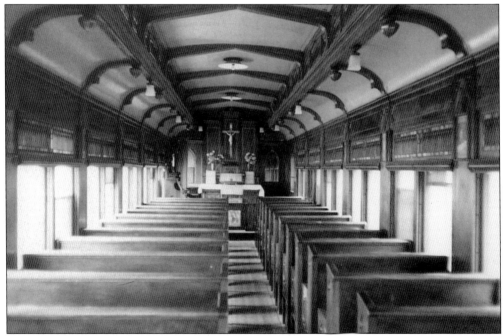

The chapel car is now in Nevada City, Montana, as a part of the state's historic ownership of Virginia City and Nevada City. Other churches in Gardiner include the Gardiner Community Church, built in 1905; the Baptist Church, built in 1978; and the Mormon Church, built from 1984 through 1985.

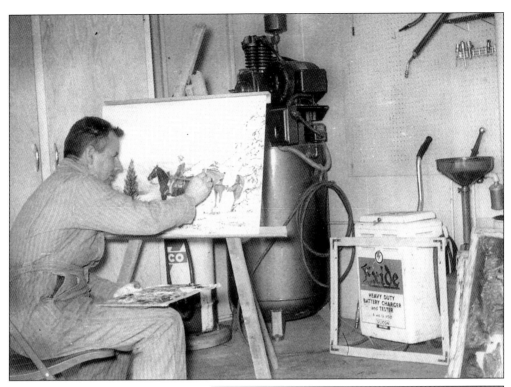

Filling station operator Warren "Bud" Hutchings occupied his idle time with painting. He also did sculpture work of many figures of wildlife. He had some of them cast.

In August of 1947, Hugh Crossen became the National Trapshoot Champion, the only grand winner to come from west of the Mississippi. He won every championship there was to win in Montana.

Built in 1903 for a bid of $1,450, the old jail stands vacant under the bridge. Remodeling of this 1930s bridge in the 1970s widened it by making a walkway on the outside of the original structure. The 1893 bridge was a half-mile downstream, and cost $10,700. The 1930s bridge cost $57,000. When the latter was finished, a community picnic and dance were held on the bridge.

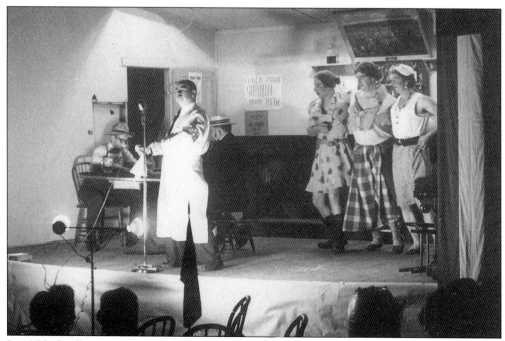

In 1956, the Crevasse Mountain Players presented the second of the plays that entertained at an elk feed which had been started in 1926. Here Tom Close, Gene Herne (hidden), Otho Mack, and John Galle entertain with a chorus line of Max French, Al Bowman, and Bill Hape. Originally only for Legionnaires, the performances were later opened for public attendance.

When the Crevasse Mountain male entertainers tired, the Gardiner women took over. I'll not attempt to identify Teddy's Rough Riders by their belly button mouths. Suffice it to say that Pat Hoppe, Marge McCoy, Margaret Manning, Rita Fredericks, and Edith Horn played these parts in 1974. The show was called the "Laff-In."

Here are Margaret Manning, Edith Horn, Florence Crossen, and Karen Hotchkiss in another of the "Laff-Ins." The show was presented in Livingston and Billings, as well as Gardiner. It raised a total of $8,000, which was given to the Northern Rockies Cancer Treatment Center in Billings.

Something new has been added in Gardiner. It is E.L.K. Inc. From the first elk call Don Laubach made in 1984, to a store full of hunting ideas, E.L.K. is there for the serious hunter of elk, deer, antelope, coyotes, and turkeys. Nine different calls are available. The first interest from overseas came from France and Japan, but Russia is now showing a desire for such hunting techniques. The store, started in 1997, has also found a good market for shed antlers.

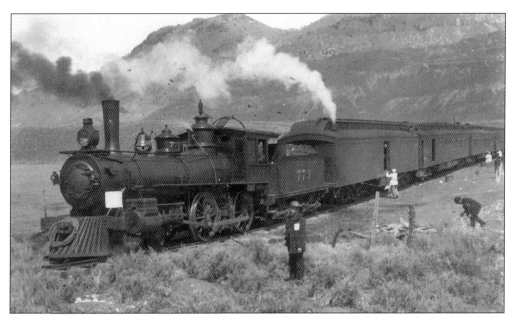

Cinnabar, Montana, served as capitol of the United States from April 8 through April 24, 1903, while President Roosevelt was in the park. His train stood there at the end of the track to which it was backed from Gardiner, where there was no turn-around at that time. If you look across the river, you can see the railroad grade around the hill (MM3).

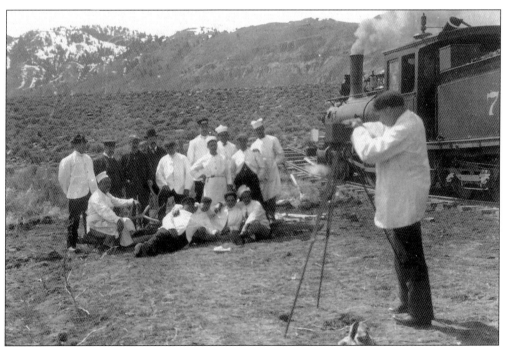

Photographers, secretaries, cooks, and trainmen passed their time fishing, reading, and writing. Wm. Loeb Jr. took care of official business. On April 16, they were challenged to a baseball game by soldiers from Mammoth. It was a welcome diversion. The Cinnabar post office closed on May 23, 1903 (MM3).

George W. Reese is pictured here with animals he killed and mounted for an exhibit that he took to the 1904 World's Fair in St. Louis. Coming to the area in 1877, he became a hunting guide, the mail carrier from Horr to Aldridge, and Sunday School Superintendent at Horr. His three sons, James, Bert, and Ira, were born on Reese Creek, where he left his name on the map.

In 1912, elk were coaxed into a corral by a hay trail and then loaded into wagons to be hauled to the train near Cinnabar. They were given a new home in western Montana or Washington. Thus were elk herds started in those areas (MM3).

Hugo J. Hoppe came to Virginia City, Montana, with the first gold seekers. There on August 6, 1864, his son Walter was born. He was believed to be the first white child born in what became Montana. For 19 years, Hugo ranched, built a hotel, and maintained a freighting outfit at Cinnabar. In 1888, he set up a sawmill on the creek that bears his name.

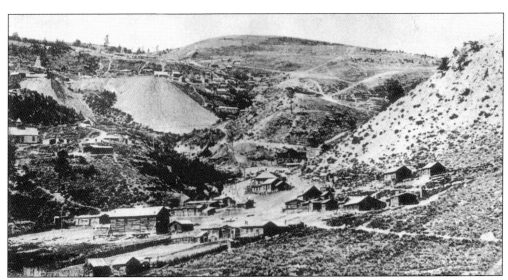

Of Aldridge, Montana, where a wonderful grade of coking coal was mined, it was said that the only level place in town was the lake. The dump showed prominently below the washer, and the black ditch ran down the hill into the lake, making it devoid of fish until after the mines closed and hatchery fish were planted (5.MM).

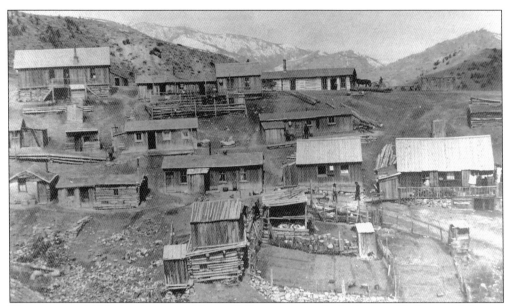

This section of Aldridge, known as Happy Hollow, was mostly the home of Italians and Austrians. These buildings were the homes of, from left to right: unknown, Cy Ford, Joe Bailey, John Schmidt, and Robert Orr. In the second row, from left to right, we see the end of Lawrence house, and then the houses of Louis Tostorvnick, Matt Shuss, and the Shuss barn. In the top row are Yurrella's Saloon, an unknown building, and Paul Rigler's Saloon. The horse was attached to Wright's delivery wagon.

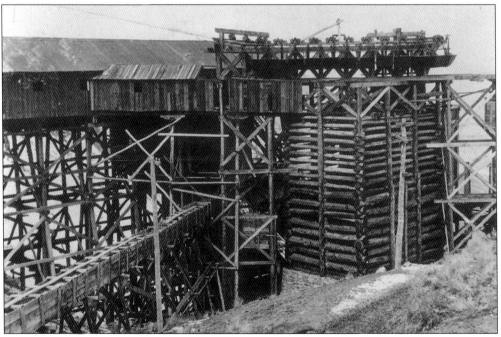

Coal came to this tipple and bunker from several mines right in town and from the Foster Mine 2 miles behind Aldridge. The flume brought coal a half-mile from the No. 4 Mine. From here it went through the washer.

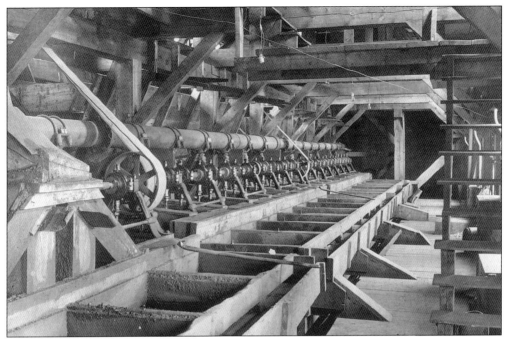

Built in 1902, this coal washer in Aldridge had many settling bins taking the slack from the coal. There were many stairs in the four levels. Children of the day remember running about the building as the washer man, Joe Golde, played with them. Bob and Tom Sommerville worked in the washer at one time—12-hour shifts at $3 per day.

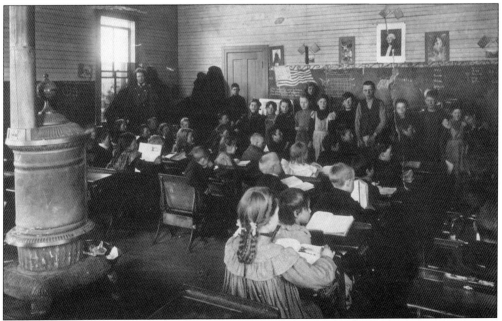

With a population of eight hundred, Aldridge had only two rooms of school until 1905, when a third room was added. Two rooms posed for this picture in 1902. All were identified by Jim Bailey (the third boy seated in the second row), who had kept the picture from the time it was taken.

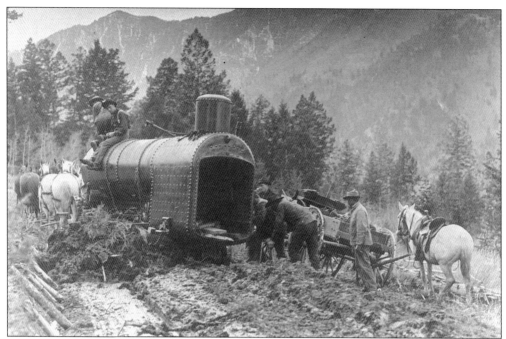

About 1906, the boiler was replaced at Jack Wilson's sawmill on Hoppe Creek. Using eight horses, it took a week to move it in. No jerkline was used. Two drivers were responsible for four horses each. Men who worked at the sawmill called their quarters the "Orphans' Home."

After Aldridge and Electric closed, Joe Narlow stayed on to roll up the cable from the aerial tram with a turntable he had built. The tram was sold to G.L. Tanzer of Cooke City. In both mining areas, there are still tram towers standing.

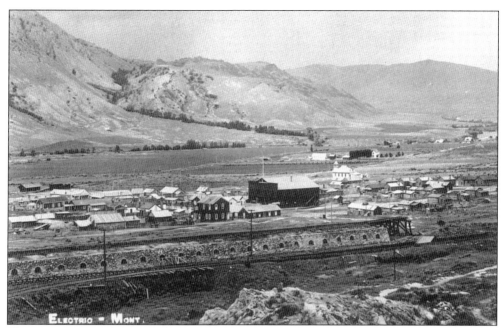

Electric, Montana, the town where 225 coke ovens burned the coal produced from the mines at Aldridge, was changed from Horr in 1904. The big Montana Coal & Coke Company Store was built in 1905. Mining stopped June 30, 1910. In 1981, the Church Universal and Triumphant (CUT) moved their headquarters here from California (MM5).

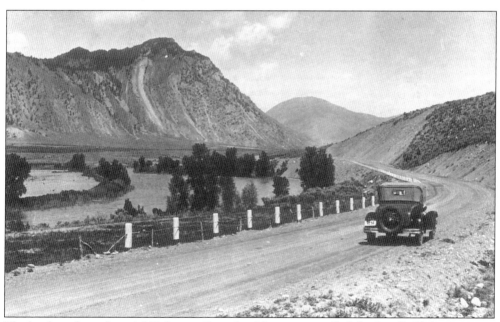

The bright red streak up 1,800 feet on Cinnabar Mountain is called the Devil's Slide. Attempts to rename it "Angels' Assent" gained no acceptance. Aldridge residents who lived about 1.5 miles behind this feature spent many a Sunday nearby. It is quite climbable. It took me two hours to climb it after I was 60. Attempts to make a motorcycle "hill climb" out of it were deterred by a big ditch at the bottom (MM5.2).

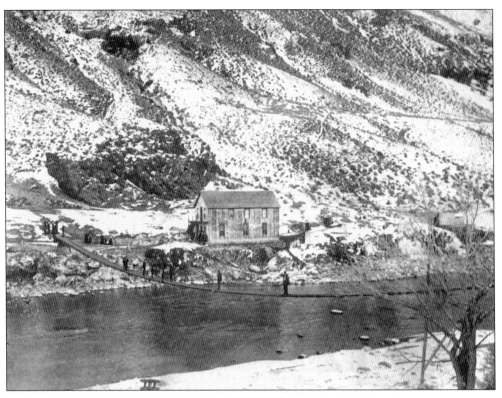

LaDuc Springs is right beside Highway 89. The LaDuc family installed a footbridge so that residents of Horr and Aldridge could come to their bathing facilities. They operated here until the business at Corwin depleted their facilities around 1912. Note the yellow geyserite formed by the spring (MM 6.8).

The tubs at LaDuc Springs were made of sawmilled lumber and held water well, they said, as long as they were always kept wet (MM 6.8).

Fred Bassett squatted near Corwin Springs, where Bassett Creek remains a name on the map. Later he proved up on a homestead in Cinnabar Basin. It became the home of his little daughter in the picture when she was married to Walter Steyers.

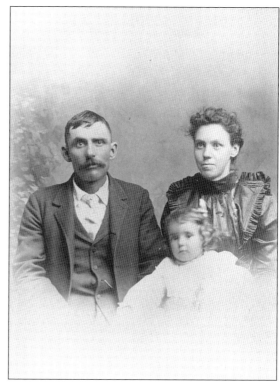

Corwin Springs was named for Dr. F.E. Corwin, resident physician at this hotel and plunge that opened in July of 1909. This large sanitarium boasted electric lights, steam heat, hot and cold water, and telephones in each room for $2.50 per day. The hot water from LaDuc Springs was brought down in a wooden flume, small parts of which are still visible from the Cinnabar Boat Launch on the west side of the river. On Thanksgiving, November 30, 1916, an early morning fire leveled this resort. It was never rebuilt (MM7.8).

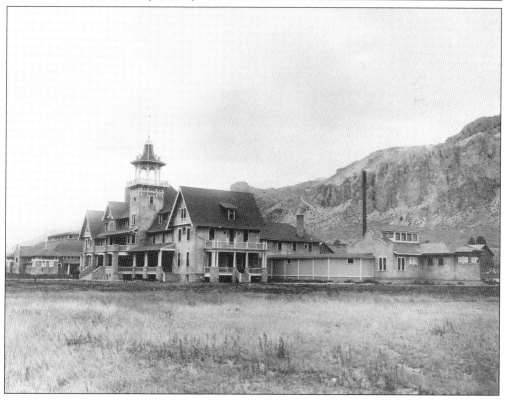

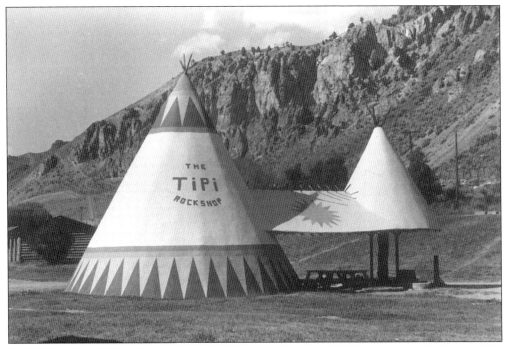

In 1929, Walter Hill, who had bought the Corwin site, put up a tipi gas station. Dude ranch facilities were nearby. Later all was changed by Welch "Sonny" Brogan, and again by the Church Universal. Various services have been offered—rock shop, restaurant, motel, and RV park.

As a tourist attraction, Sonny Brogan kept a pen of elk, first at Corwin, and later east of the road in a substantial pasture. When accused of letting wild elk join his herd, he shifted to buffalo (MM8.2).

Two

Yankee Jim Canyon and the Wild River
Mile Marker 10 Through 18

You have left the ghost town area. Here you will find the colorful characters who exercised control of transportation and visitation to Wonderland, as Yellowstone Park was called in early days. The first wheeled vehicle went through the canyon on October 7, 1872, as the diary of Bart Henderson recorded. Before that, there had been a wheeled vehicle taken into the park by Matthew McGuirk in 1870. He had taken apart a wagon and transported it through to the Mammoth Hot Springs, where he was commercializing on the medicinal waters.

The road up Cedar Creek leads to the old OTO, the first dude ranch in Montana. This is a picture of "Pretty Dick" Randall taken by F.J. Haynes at Mammoth Hot Springs in 1890, when Dick was serving as a guide in Yellowstone Park. He had charge of the stage coach horses at Upper Geyser Basin. Many members of European royalty got their first taste of the American West as a result of Mr. Randall's efforts (MM10).

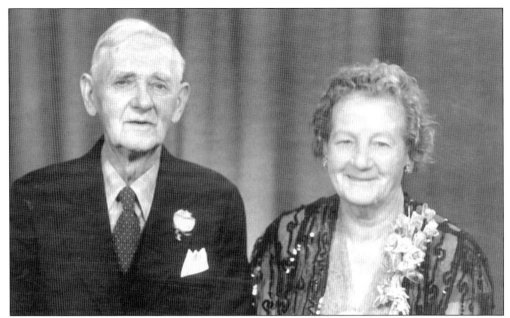

Dick and Dora Randall established the OTO in 1898, and operated it until they sold it in 1932. It is now Forest Service property. There, Elder Hostel guests and even travellers from foreign countries pay for the privilege of rebuilding the facility. The cabins are not yet habitable. Most of the workers live in tents.

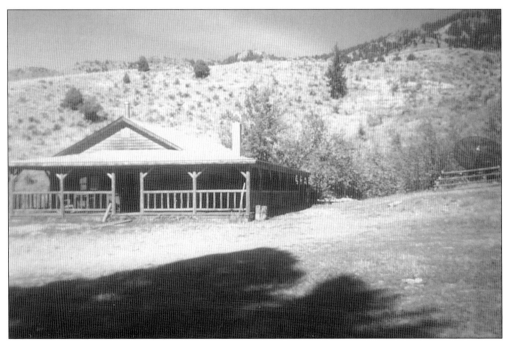

This is one of the lodge buildings at the OTO in September 1991, when friends and I visited there. There was a hot tub on the porch and furnishings in the kitchen. Note the TV dish to the very right. A 1924 news article reported that Dick Randall was having movies taken at the ranch. He used these in advertising on his trips east.

Robert E. Cutler lived the turbulent life of a rough frontiersman. Better known as "Buckskin Jim," his dispute with the Northern Pacific over the townsite of Gardiner was directly responsible for the 19-year delay in the extension of the track to that town. He killed a neighbor in self-defense during an encounter and argument over an irrigation ditch. He lost his life in the Yellowstone River, but he left his name on the map as Cutler Lake.

Harriet Ball came as caretaker for Mr. Cutler's children after his divorce. After they were married, she bore him three more sons. She was a real lady. She had taken a few painting lessons before she came to Montana. She painted 20 moose horns after she was 80 years old. These are four she did for the Whithorn family.

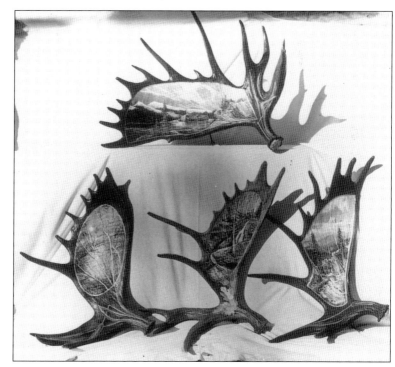

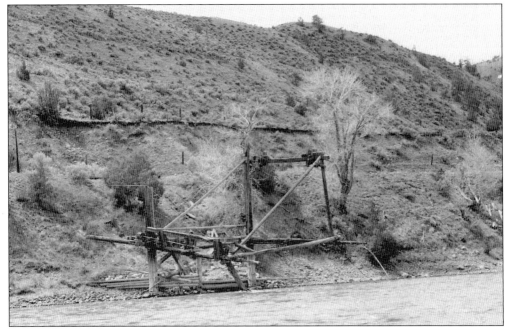

The remains of an ingenious waterwheel to lift water from the Yellowstone River for irrigation withstood the high water of many a June. It was built by the three younger Cutler sons. Halfway up the hill is the scar of an irrigation ditch dug many years before in an attempt to bring water from Mulherin Creek to the flat Cutler land (MM 10.3W).

For many years, the cable which hung across the Yellowstone River below the Cutler ranch buildings reminded them and the Rigler family of the cable car in which the boys pulled themselves across the river for school, held on opposite sides of the river in alternate years. Remnants were still visible in 1962 (MM 12W).

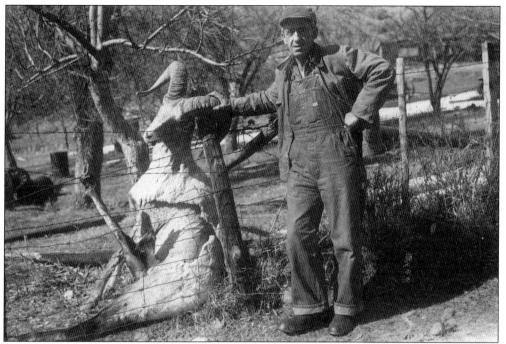

One morning in April 1959, when Frank Rigler got up at his ranch home, he found this mountain sheep dead on his fence. Its full curl horn had made a fatal hook on a post. Rudy Planishek posed with it. (MM 11.1E).

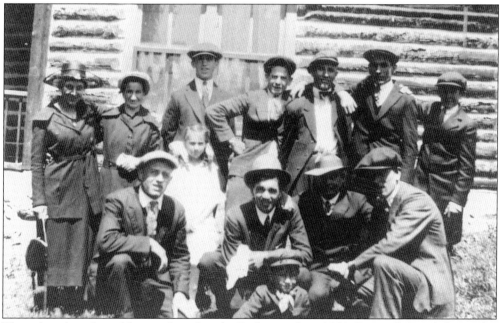

These friends and neighbors gathered at the Rigler ranch in 1921. Pictured, from left to right, are: (front row) Jack Gurzant, Elsie Pirtz (Crane), Joe Pirtz, Frank Koncilya, and Charlie Rigler; (back row) Fannie Pirtz, Cecilia Rigler, Paul Rigler, Vince Rigler, John Glotch, Dave Rigler, and Frank Rigler (MM11.1E).

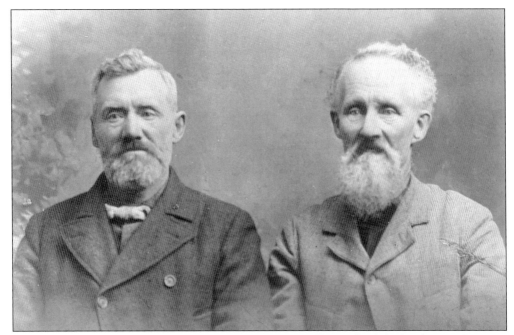

These two pioneers of Montana pre-dated Livingston. Bill Lee (left) had a ferry at Benson's Landing, 3 miles east of the site where Livingstons came to be. Yankee Jim was James George, who took over the road through the canyon that carries his name.

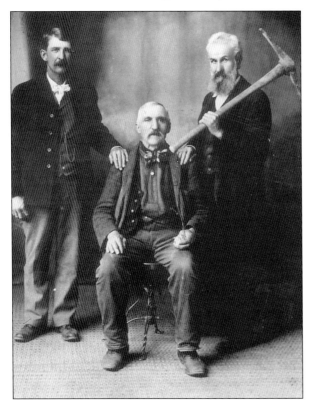

The creek and the trail that leads to the back country above Rigler's place are named for Joe Brown. He is said to have been the first to discover gold in the Cooke City area. Horn Miller also lived in this area and later went to mining in the Cooke City country, where he left his name. John Curl was a Cooke City miner who stayed there. From left to right are: Curl, Miller, and Brown (MM 12.5E).

James George came to the area in 1873. He squatted above the canyon and took over the wagon road, which had been constructed the previous year by Bart Henderson and Adam "Horn" Miller. He built a way station and charged toll over the road. Henderson and Miller had built the road to take mining supplies by wagon into the Cooke City area.

Yankee Jim's toll gate was between the house and barn. Toll charges were $2.50 for one wagon and one team of horses or mules; $1.50 for each additional team; $1 for a single horse and rider; 75¢ for a pack horse; and 5¢ for each head of horses, cattle, or sheep (MM 12.6W).

In 1963, Bob Stewart, who as a boy had remembered the old toll collector, stood atop what he called "Yankee Jim's Guard Rail," a part of the construction that is very evident along a section of his road which is not now used at all.

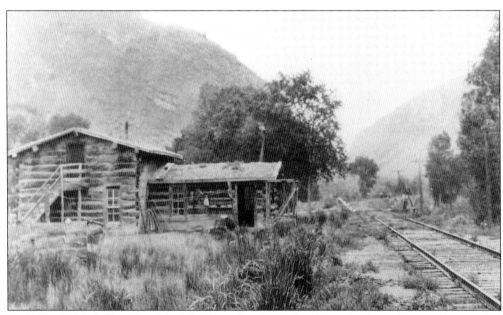

In 1883, the Park Branch of the Northern Pacific Railroad was built in the very dooryard of Yankee Jim's way station. The railroad took his road over the south hill and built for him a much inferior road, which he considered very unsatisfactory. Jim sued the company without success. Finally, in 1893, Park County paid Jim $1,000 for his road, and the public could travel through the canyon free of toll.

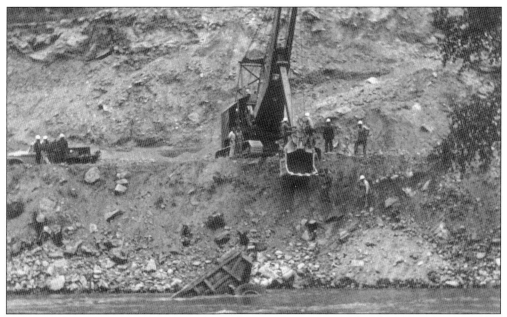

During road construction in 1962 on the road across the river from the old toll road, Pat Staples, driver of an EUC for Baltrusch Construction Co., was able to jump from the truck before it went into the Yellowstone River. Here it was being drawn out of the river two days later (MM 14).

On July 29, 1961, Bill Kidd of Great Falls brought his 16-foot fiberglass Beuhler Turbocraft to Yankee Jim Canyon to demonstrate how it could function in 6 inches of water. It was powered by a regular Plymouth motor housed under the seat. The opening size changes the speed; the deflection of the stream determines the direction of travel. Kidd and Ken Boles stopped here to fish.

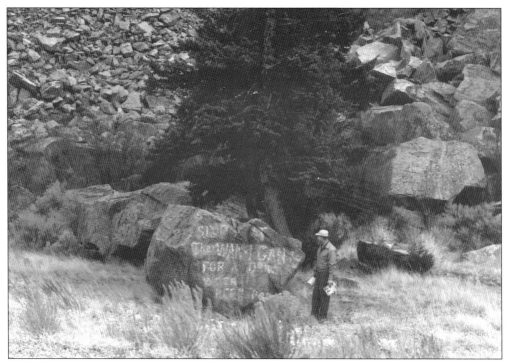

Armed with a bucket of paint and brush, I proceeded to place Wan-I-Gan advertising on the rocks in Yankee Jim Canyon. The Forest Service took a dim view of my work. Here, Steager Perdue accompanied Bill Whithorn to cover the offending words. The original paint has proved better than the cover job and is still visible (MM 15.1).

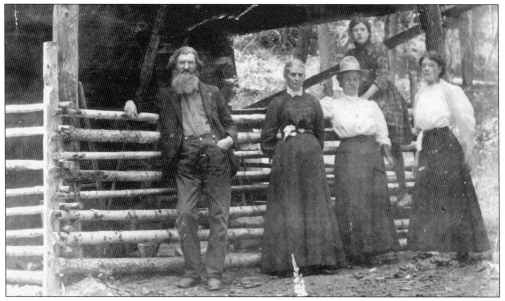

Thomas J. Miner first came to herd stock for W.W. Alderson of the Gallatin. For $50 a month, he furnished his horses and board. He stayed on to trap and leave his name on the map. In the early 1890s, he went mining at Crevasse. Officials claimed that his dump was in Yellowstone Park. He moved to Washington to live out his last years.

Tom Miner School was District #1 in Park County. Pictured here is picnic fun for the male patrons as they are "horsing around" riding the beer keg. Built of rock, the building was very substantial. One room served as teacherage (home away from home for the teacher).

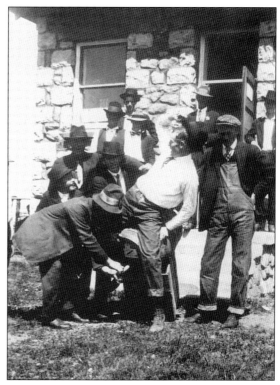

Edward Merrell arrived here in the 1880s with his brother, en route to Jackson Hole. They landed jobs haying for Sam Dailey, who let them stay the winter in a cabin on his cattle range in Tom Miner Basin, with free wood and game meat. Merrell took squatter's rights to nearby land, married the local teacher, and lived out his life where a lake is named for him.

Tom Miner Basin has been known for the large number of petrified trees in its upper reaches. About 30 years ago, the Forest Service initiated a $5 charge for 25 pounds of the petrified wood. In 1990, that was changed to a free piece 1-cubic-inch in size. Here is a stump of a petrified tree 14 feet in diameter at the head of Rock Creek. Pictured, from left to right, are: Bill Sherwood, Jim and Maggie Bailey, and Bob Stewart.

Alex Stewart worked in the Aldridge mines until March of 1907, when he took a desert claim of 85 acres on Rock Creek, next creek below Tom Miner. Margaret Stewart baked bread to sell to the trainmen who stopped at Carbella, where the Stewarts had the post office. Bob and Jim stayed with the ranch, which became 7,000 deeded acres. Shown here, from left to right, are: Sandy, Bill, Mother Margaret, Bob, Jim, Father Alex, and John.

Three

UPPER
PARADISE VALLEY
MILE MARKER 19 THROUGH 27

Here you have entered the upper part of Paradise Valley. The high mountain border, the tame river, and a mild climate encouraged Native Americans and early settlers to live and winter here. Washington Irving described it well through the words of Crow Chief Arrapooish: "The Crow country is exactly in the right place. Everything good is to be found there." All of his comparison is found in *Captain Bonneville's Adventures*.

Here we find an area where Stands, Hepburn, D'Ewart, and Blakeslee family members have lived for nearly a century. We find the peaks of Emigrant Mountain dominating the landscape. We find the recreation furnished by Dailey Lake, fruitful hunting areas for wild game, and mountain-climbing experiences for the rugged individual. From the top of Emigrant's highest peak can be seen, even on small 35mm slides, the dominant peaks 100 miles away.

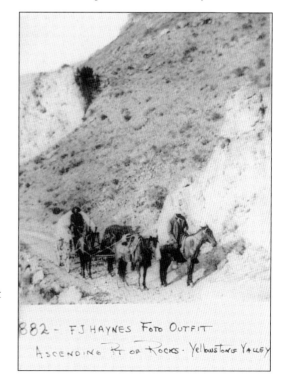

The Point of Rocks was considered a considerable barrier to transportation before Bart Henderson made road building over it a prelude to building through Yankee Jim Canyon. Shown here is the outfit that F.J. Haynes, official Yellowstone Park photographer, used in ascending the Point in 1882 (MM 20W).

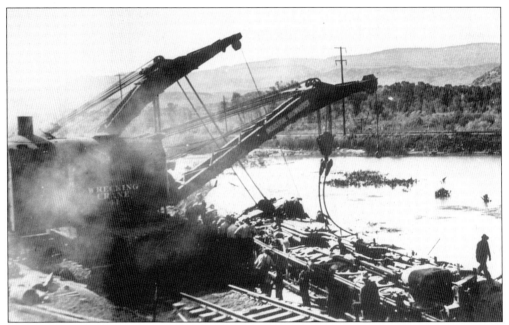

The very high water on the Yellowstone in June of 1918 caused problems in many areas. Where the tracks of the Park Branch of the Northern Pacific were squeezed between the Point of Rocks and the Yellowstone River, there was the railroad disaster pictured here.

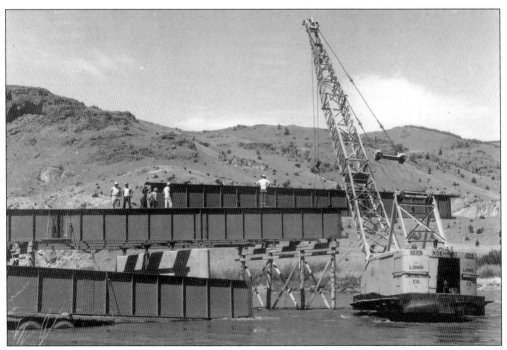

The Yellowstone River Bridge near Point of Rocks was constructed before high water in June of 1958. This is a May 19 photo. After Highway 89 crossed to the west side of the Yellowstone River, the Point of Rocks Lodge was built in 1963 by Max and Carleen Chase, members of the D'Ewart family who first bought ranch land around here in 1903 (MM24).

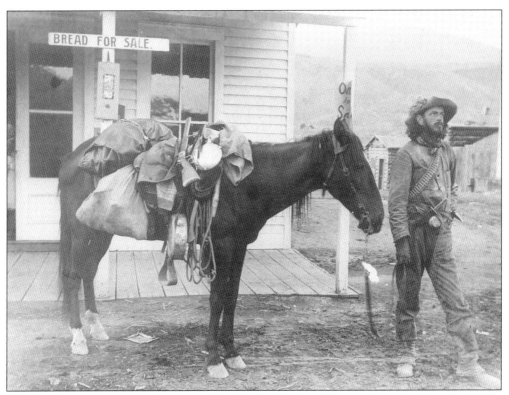

Bill Donahue was a trapper, hunter, and guide who had a cabin on the creek where he left his name. He is shown here in front of the Settergren Store in Gardiner about 1900.

Near the scraggly trees where Donahue Creek comes to Highway 89, there stood for many years a large, two-story house. It had been the home and way station of Sam Dailey. In the 1970s, it was taken apart log by log and reassembled near Bozeman for a home.

The Zimmerman house up Donahue Creek looked rather sturdy when we visited it in 1985. It had stood vacant since Mabel's death in 1939. As a "fun thing," Elizabeth Hughey has had the house rebuilt. She has built her own very large home nearby (MM21.2).

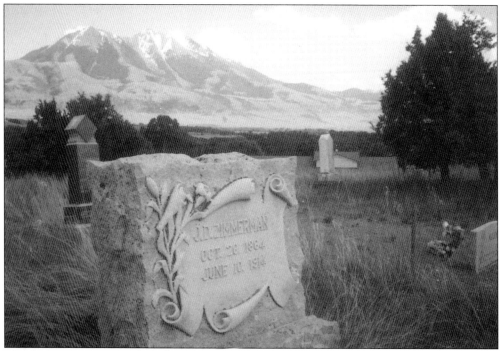

This large, ornate stone marks the grave of J.D. Zimmerman in the Emigrant Cemetery. Records indicate that Mabel is buried beside him, but there is no marker at her grave. She stood trial for murdering him in 1914, and, though she was freed of the charge, it is said the lawyer got the ranch.

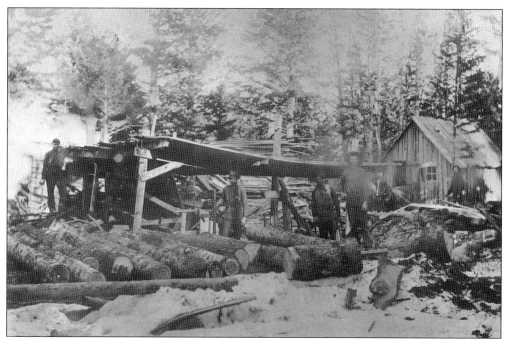

At one time, it was said that Kenniston's sawmill produced more lumber than any site in Montana. Shipped from a railroad track right of way on the Park Branch, the business that served the workers by E.B. Kenniston was later known as "Slab Town." The old lumber from the buildings has brought good prices elsewhere (MM23.2).

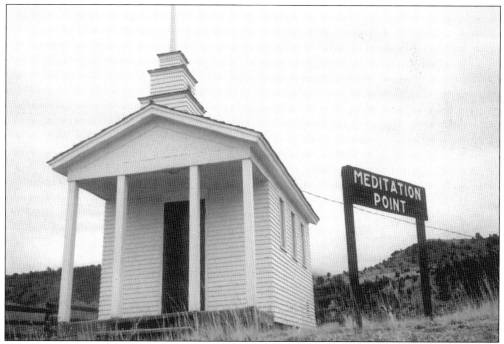

Near the Highway 89 rest stop is the little chapel called "Meditation Point." It was built with Con and Betty Douma's 25th wedding anniversary money in 1966 (MM23.8).

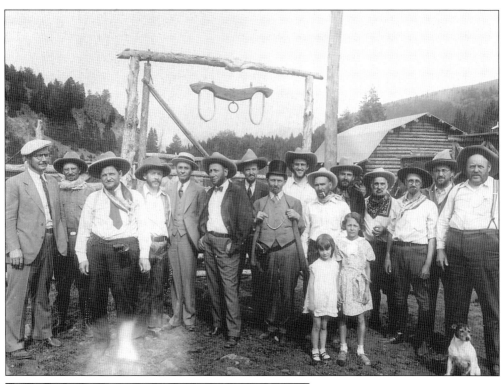

Guests such as these in 1933 came from far and wide to enjoy western hospitality. After selling the ranch in 1977, Jim and Gayle Murphy retained the Ox-Yoke brand at their home just south of Emigrant. The Dude Ranch on Big Creek is now called Mountain Sky Guest Ranch (MM 24.2).

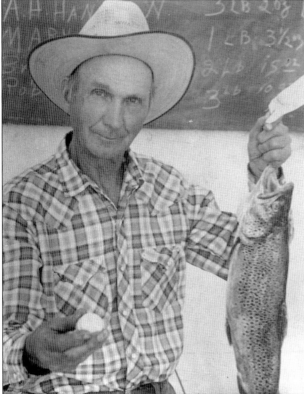

This is Rupert "Dooley" D'Ewart with the 5-pound, 5-ounce Lock Leven trout that won the 1,000 silver dollars and the first prize in the Fish Derby in 1966. That year the Derby drew 1,500 entries. D'Ewart used a bullhead for bait. He made his catch 25 minutes after the 9:00 a.m. opening near Point of Rocks. The Derby started in 1941 and stopped after the 32nd one in 1977, because of difficulty in getting 10 miles of stream access.

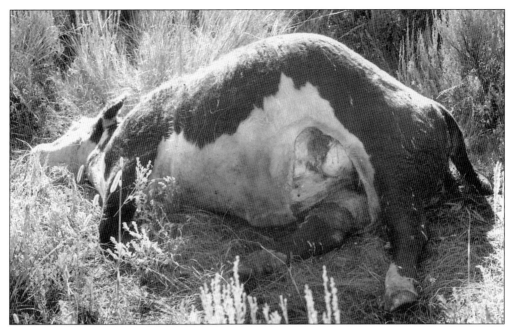

This cow is believed to have been the victim of a UFO visitation in September of 1975. The cow, belonging to Floyd Petersons, was found in this condition in its high mountain pasture on Big Creek. The udder and vaginal and anal openings had been taken out. Only flies touched the carcass.

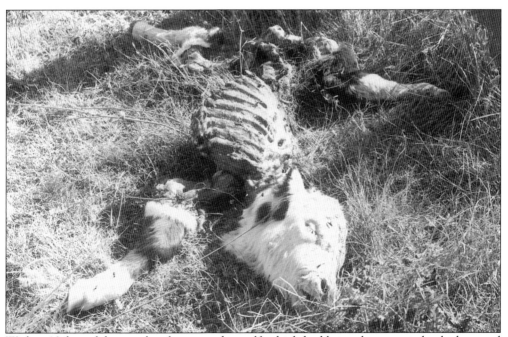

Within 10 feet of the mutilated cow was her calf, which had been almost completely devoured by predators such as coyotes, ravens, magpies, and other animals. It had evidently hung around the mother until it starved. The Petersons took Bill Whithorn to this pasture 2 miles northeast of the Ox Yoke Ranch to take the pictures on September 21, 1975.

Sam Dailey left his name on the map at the place where Kenniston's lumber was loaded out. Sam fathered five sons—Alfred, Arthur, Harvey, Charles, and Henry—all of whom once lived on ranches in Paradise Valley. Now there is not one Dailey living here.

Sam Dailey built this big barn that is put together with wooden pegs, which, it is said, can still be seen. The upstairs rooms in the house were rented out. After Sam's death, his son Arthur lived here. Claude Hookham bought the house in 1944, and Floyd Petersons then bought it in 1960 (MM 24.6). At MM 25, look for a fish hawk nest atop a high pole to the left of the road.

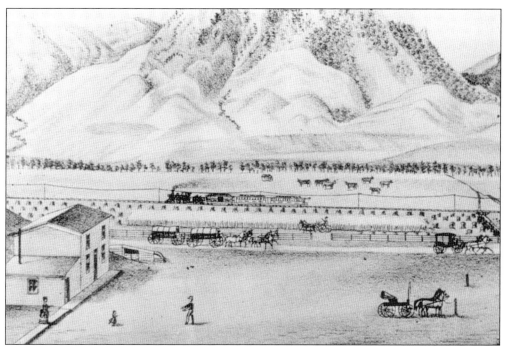

In December 1867, Fred Bottler chose a place near the seven springs for the first permanent ranch in Paradise Valley. His first home was a log cabin. His second is pictured here as it was in Leeson's 1885 history. He hunted and guided early visitors to the valley. During his first survey of Yellowstone Park, Ferdinand V. Hayden established his permanent camp at Bottler's and hired Fred Bottler as guide and hunter for the party for $103 per month (MM 26.6).

Bottler built a spacious 3-story, 21-room home in 1893. It had an ornate interior and water to the third floor. Among his famous guests were the Earl of Dunraven and Col. P.W. Norris. The house burned in 1900, and was replaced by one now belonging to Doug and Martha (Story) Drysdale. It is one of the bed and breakfast businesses in the valley.

If you had elected to use the road on the east side of the Yellowstone River, you would have come to the cabin where Johnnie Hepburn used to display his many artifacts found after slides in the nearby Chalk Cliffs. His garage was covered with old license plates. A grandson now lives there.

A petrified turtle was Johnnie Hepburn's much-prized possession. He left his name on Hepburn Mesa, the flat above the Chalk Cliffs. In 1891, Johnnie captained the *Zillah*, the first steamboat on Yellowstone Lake.

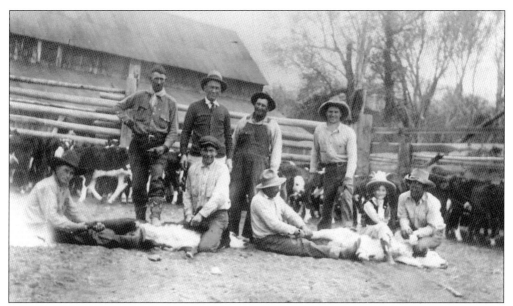

Branding time in the valley always involved all the neighbors, even the children who came for the gala event. Here is the group that gathered at the ranch owned by Dr. Townsend. His man on the ranch was Tom Williams. Pictured, from left to right, are: (kneeling) Ernie Emory, Stanley Keough, Tom Williams, Wanda Mae Townsend, and Walter Pressley; (standing) Walter Morgan, Dr. Townsend, Joe Stands, and Alvin Stands.

Joe Stands came to Paradise Valley in 1890. He mined in Emigrant Gulch and cooked for the Daileys' cattle camps. In 1893, he squatted on a claim in Stands Basin at the foot of Stands Peak. He bought a full section of railroad land. After he married Molly Dorgan and had a family, winters forced him to take a homestead on Six Mile.

The antlers are prized possessions of big game hunters. Jim and Alta Stands conducted a big game guide service for years. Because they had several fall babies, Grandma Whithorn got to go to hunting camp some years. I loved it. Here are some of Jim Stands' hunters packed for the trip home.

For a bedtime snack, Charlie and Debbie Blakeslee seemed to have picked up some pretty hot stuff—dill pickles and Tabasco sauce. It makes one wonder what the cat has in mind!

Dailey Lake and Dailey Basin are named for Andy Dailey, who was one of the five children of the Ebenezer Daileys who wintered in Paradise Valley in 1866 and 1867. The family went to Oregon for four years, but returned to Montana. Andy married a widow from New Hampshire. He built a big house (complete with bathroom but no piped-in water) in 1917.

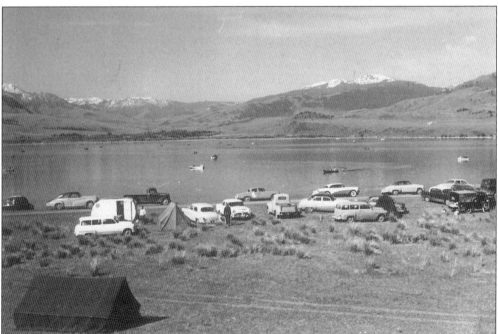

During the 1950s, when fishing in Dailey Lake was closed in the winter, opening day brought out many fishermen and their crafts. On this day in 1955, 208 boats were counted for the day. On May 12, 2000, Walleyes Unlimited sponsored a Day at Dailey Lake to introduce 250 kids to fishing by taking them to the Lake from 9:00 a.m. to 2:00 p.m. for lessons and boating experiences. Of the 16 Walleyes Unlimited chapters in Montana, the local chapter is the largest.

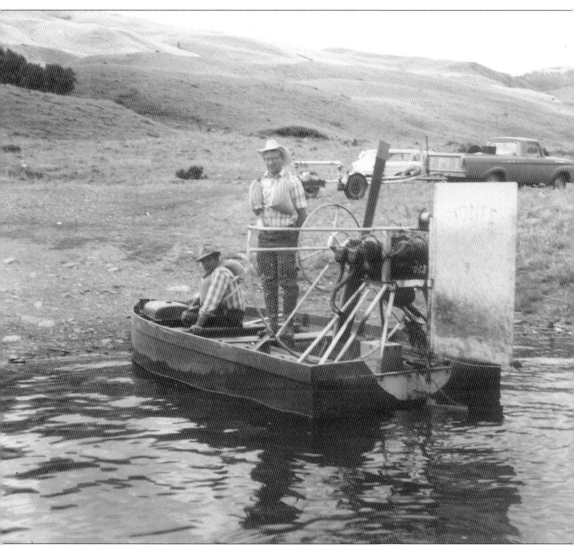

In 1965, Walt Martinez and Orville Anderson of Big Timber brought this airboat to Dailey Lake for a day of recreation. Driven by a 65-power Piper Cub airplane motor and propeller, it showed its practical use in the area of heavy reeds, where ordinary motors become hopelessly entangled. They got into the reed beds of the big fish. In 1965, this airboat was one of eight in Montana. It was used to string power lines across the Missouri River for Wilson Construction Co. of Helena. On Dailey Lake it skimmed across the water at 40-miles-per-hour. It used 5 gallons of gasoline per hour of operation.

Four

BUSINESSES OF
PARADISE VALLEY
MILE MARKER 28 THROUGH 36

Settlement of Paradise Valley required services for those who chose to make it their home. Here, in about the middle of the valley, those businesses grew. First they were west of the Yellowstone River. About 1928, the highway was built on the east side of the river, and businesses grew there. Now since 1965, Highway 89 goes from the Point of Rocks to Livingston on the west side of the river. Still much activity is evident in both areas.

Therefore, in this chapter, I shall deal with Emigrant and Chico Hot Springs as currently busy places. But I shall give some attention to Old Chico and Wan-I-Gan, for they have been busy places. I intend, eventually, to deal with all the Chico area in a compilation of information I have accumulated about the gold mining area of Emigrant Gulch. For your information here, I would like to throw out the fact that mining in the whole area dealt with coal on the west side of the Yellowstone River but with metals like gold or silver on the east side of Yellowstone.

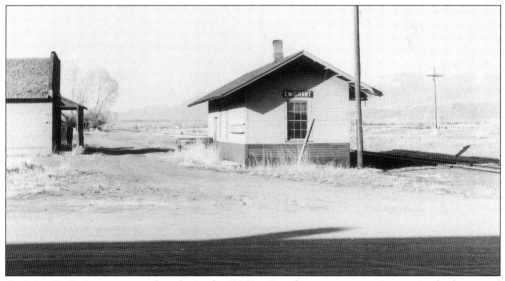

Activity in Emigrant was nil early in the 1950s. Regular passenger train service had stopped September 13, 1948. Ab Armstrong's saloon had been closed for 30 years. There was no road building at this time. Then life breathed again in Emigrant. The depot was moved to become a home between Gardiner and Jardine. Elmer Armstrong opened the Old Saloon on March 17, 1962. Highway 89 construction from Emigrant toward Livingston resumed.

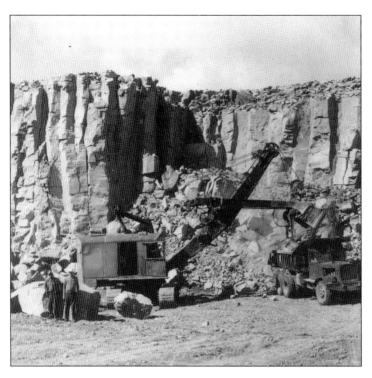

The lane to the left leads to the old Merriman Quarry, which operated seasonally from the 1930s until the Park Branch tracks were taken up in 1976. Product of this quarry was of two kinds. Riprap was the name given to large rocks taken out to put near bridges on the streams where the Northern Pacific trains crossed. During high water there was always the danger of the banks washing. Ballast was crushed rock used to build the roadbeds of the railroad tracks (MM28.5).

This was one of two quarries the Northern Pacific had in Montana. The other was near Clinton about 20 miles east of Missoula. They alternated in their work so that the employees moved back and forth between the two quarries. Besides the regular quarry workmen, there was a blasting crew of about five men. At the time they worked here, Bill Spiker was so badly hurt that he died of his injuries in June 1952.

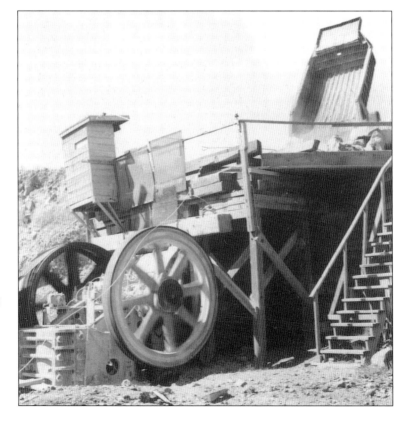

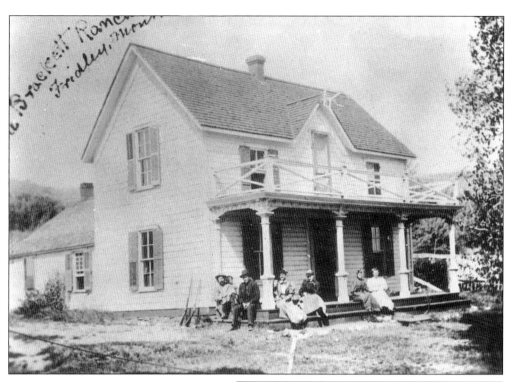

Since the 1880s, the Story name is in the sixth generation of connection with this ranch a mile south of Emigrant, either as partner, mortgagee, owner, or resident. Shown here in 1902 are Matt Black, Julia Brackett, Frank Mounts, Mrs. Brackett, Rosa Black, and Ida and Augusta Larsen. In 1919, this house was torn down to make way for the large white house presently located here, home of the Pete Story family (MM29.9).

The Story Ranch has been the site of several rendezvous of the Black Powder enthusiasts. Many of them come with their tepees and stay a week or two. Some bring crafts to sell or to teach to others. This was taken September 3, 1983. Sometimes Pete Story serves deep-fried rattlesnake and mountain oysters.

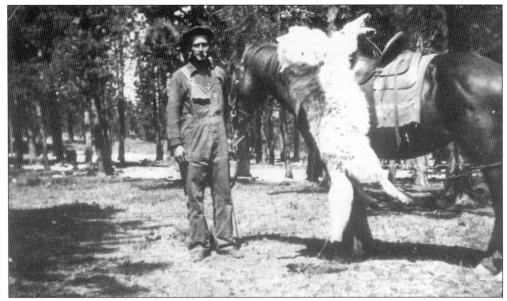

Al Close lived in the Belt Mountains in the 1930s, and there he killed the white wolf—the only wolf in the state doing damage. When he moved to Emigrant in the 1960s, he brought along the picture of his victim. Bill Whithorn copied it. Al had a fire in his home, but he got a picture of his white wolf kill in his Christmas stocking that year.

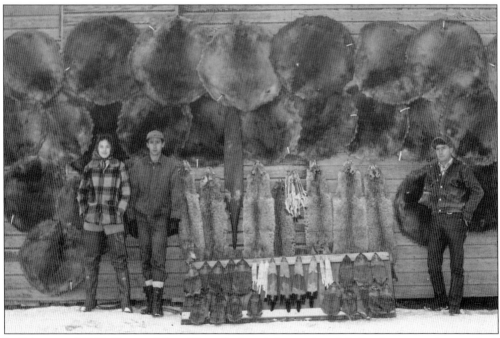

In February of 1960, Don and Roy Close displayed the results of their winter trapping on their barn. Shown off were the skins of 32 beaver, 17 muskrats, 4 mink, 16 weasels, 7 bobcats, and 1 otter ready for the fur buyer.

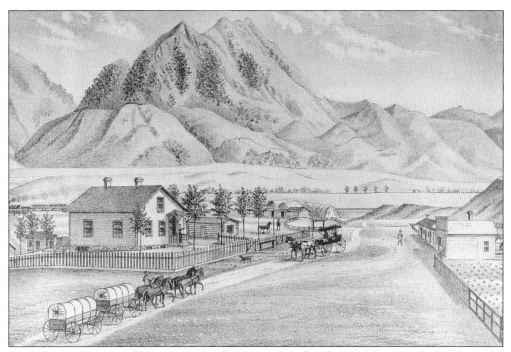

In 1885, Franklin F. Fridley got a post office named Fridley for his cabin people. He wanted a rail station, but there was a swamp between his house and the railroad. He put a platform a half-mile below, calling it Emigrant to attract Emigrant Gulch miners. At his death, the post office moved to the railroad station. The town had two names: it was called Fridley for the post office, and Emigrant for the railroad. In 1911, both became Emigrant.

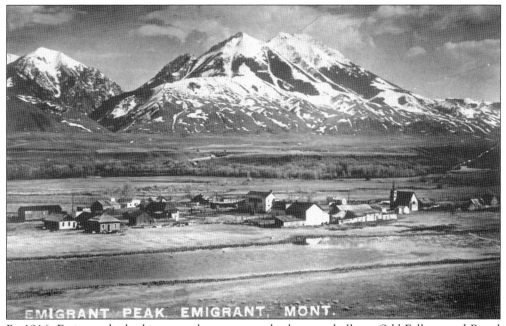

EMIGRANT PEAK, EMIGRANT, MONT.

By 1916, Emigrant had a big general store, several saloons, a hall, an Odd Fellows and Royal Neighbor Lodge, and a church—but no school in town.

This shows the saloon of Herman Kahle and the Cottage Hotel built by Kahle in 1896. Many different people ran the hotel: Grant Milligans, Bill Harris, Langs, Millie Hoglund, and Annie Armstrong. When the McNeils had the building in the early 1950s, it was their home, a store, and the post office.

At Fridley in 1907 were Bert Goudy, Lark Dunn, Clarence Keough, (?) Dunn, A.W.T. Anderson, and (?) Dunn. They were loitering on the hotel porch.

This house was called Fridley Castle when built by M.M. Black in the 1880s. It became the home of Dr. and Mrs. (Edith Black) Collamer when they were married in 1901. It burned in 1913.

Al Pfohl stands on the depot platform with his catch, the biggest trout caught in the Yellowstone River. It weighed 23.5 pounds. Otto Melin said he caught one on a set line that weighed 33 pounds, but he didn't tell anyone, because he didn't have a license to fish.

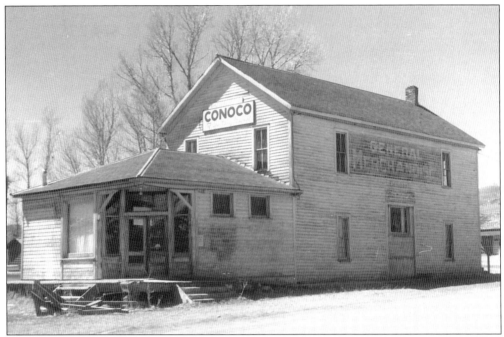

Built in 1898, this 24-by-48-foot building served as a store downstairs and a social hall above. A.W.T. Anderson was storekeeper for 41 years. Hurley Worthington had it for 11 years, and then sold out the stock at auction and the building to the McNeils. Local citizens bought it for a community hall. With paint and carpentry inside and out, it was truly a community project.

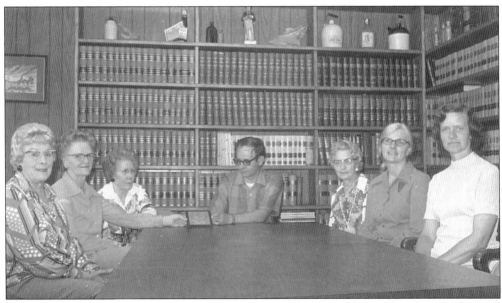

The first function held in the community's hall was a dance and carnival to benefit the Park County Cancer fund. Peg Murphy was local cancer chairman for several years. Here is the 1974 cancer committee meeting with David DePuy, county chairman. Pictured, from left to right, are: Ann Armstrong, Doris Whithorn, Agnes Vink, David DePuy, Florence Stands, Doris Pirtz, and Irene Allen.

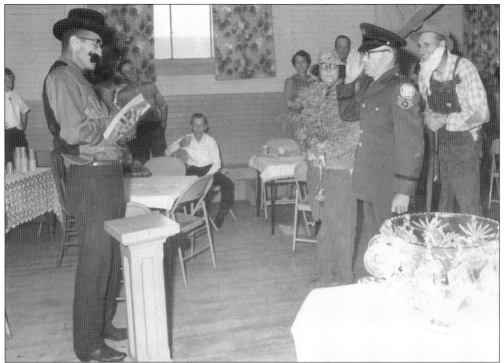

Many functions were held in the hall. This was a mock wedding for the 25th anniversary of Tom and Thelma Gray on May 19, 1967. The preacher is Scotty Chapman, the bride is Terry Willard, and Ralph Hepburn is the groom. The father of the bride is Alvin Pierce.

A musical play entitled *Home on the Range* was directed by Bernice Blinn. Here, she prepares her son John for his part on May 19, 1961.

The store building-turned-community hall burned on July 25, 1970. As the fire died down, the directors called for a meeting, and plans were made to rebuild as soon as many disagreements could be ironed out. A cinder block building was ready for a dance to ring in the 1971 New Year, as promised by contractor Dick Lundgren.

Highway 89 was extended from Emigrant about 10 miles north in 1960–1961. Bob Saffo bought land east of the highway and started this store in 1971. Bert and Kris Otis have owned it since 1989, and it has become well stocked. In 1991, a laundromat and gift shop were added to the complex.

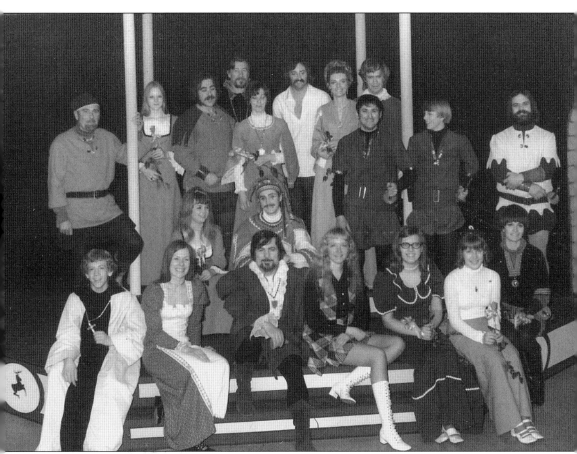

In March of 1974, Shakespeare's *Twelfth Night* was performed for six nights to standing-room-only crowds in the new cinder block hall. The cast of characters are, from left to right, as follows: (front row) Tim Lewis, Judy Bergsma, Dick Cavanaugh, Lexi Cowan (Marsh), Tammy Fredericks, Cindy Fredericks, and Jane Jordan; (center row) Becky Douglass and Gatz Hjortsberg; (back row) Archie Allen, Barbara Close, Dwight Riley, John Rogers, Eileen Story, Russell Chatham, Barbara Cavanaugh, Chico Horwath, Kent Douglass, Robert Story, and Bill Warfield V.

The Old Saloon was operated by Ab Armstrong when it opened in 1902. Since Elmer Armstrong reopened it in 1962, it has had a number of owners, including Charlie Pierces, Dave Ogans, Inverness, Dave Becks, and the current owner, Bob Fjelstads. On the ceiling, "OLD SALOON" is spelled out in paper bills, most in the denomination of $1, but there are a few older ones of larger denominations that show through the smoke which has accumulated on them over the years.

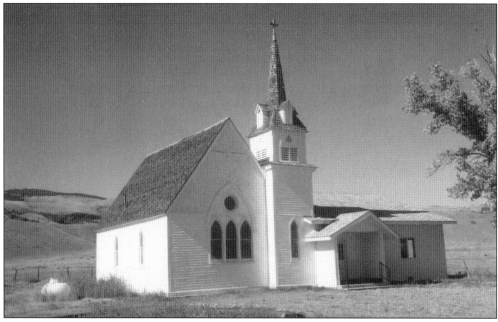

St. John's Episcopal Church was dedicated in July of 1900. Through the generosity of Dr. and Mrs. Townsend, a hall was built on and dedicated on November 1, 1953. That hall, which was separated from the church proper, was sold to Bryan and Sally Wells and became a home in Old Chico. A new hall, which opens into the church proper, has indoor restrooms and a kitchen. It was dedicated on March 21, 1981.

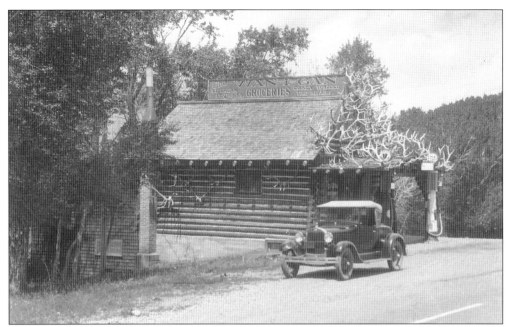

After construction of Highway 89 on the east side of the Yellowstone River in the late 1920s, A.W.T. Anderson built this home and store for his son Ted and wife Connie. First called Elkhorn Cabin, A.W.T. changed it to Wan-I-Gan when he thought of a *wanigan* being a supply craft for logging boats, hence a place of supplies on the river. That was what this was—a place of supplies on the river bank.

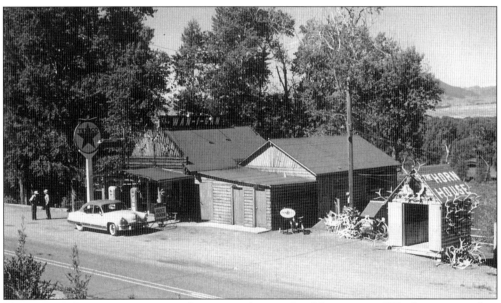

The Wan-I-Gan grew in size and services during the 28 years we Whithorns owned it (1948–1976). Twelve cabins were available for tourists, fishermen, hunters, and (for 17 years) Dr. Townsend's patients. Those cabins were marked by births, deaths, and recuperations. The Horn House, built by Tom Murray, was added in 1954. The Wan-I-Gan ceased being a business in December of 1983.

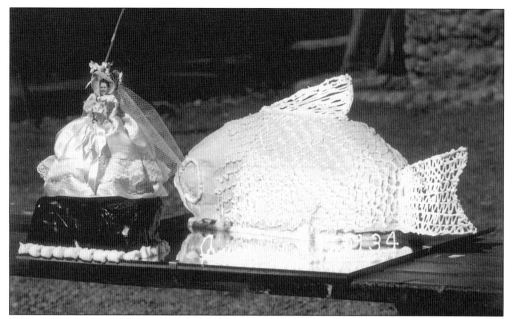

I frequently made wedding cakes for local couples. This was a 25th anniversary cake I made for my best friend, Marge Miller, and her husband, George, who was proprietor at the local fish hatchery. Marge (Bill made her face) was standing on a chocolate bank catching a fish (of rainbow colors inside). The caption read, "The day Marge caught a fish, August 30, 1934."

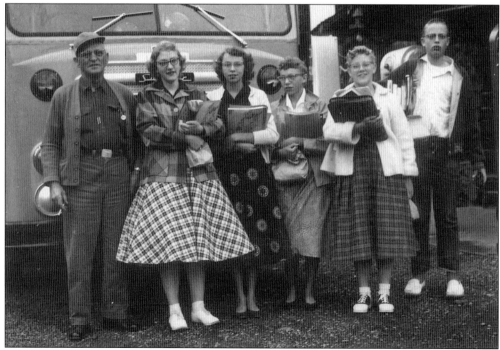

Earl Rogers was a school bus driver for over 20 years, first in his own bus, and then in a district-owned bus. Here, in 1957 with Carol Whithorn, Annette and Evelyn Conlin, and Alta and Bruce Whithorn, Earl was starting as he did each day from the Wan-I-Gan.

Frances and son Albert McLeod were customers at the Wan-I-Gan, but they were often called to be employees. Their services were also used by local ranches and the resort at Chico Hot Springs. Many local ranch residents were employed by Paradise Valley businesses.

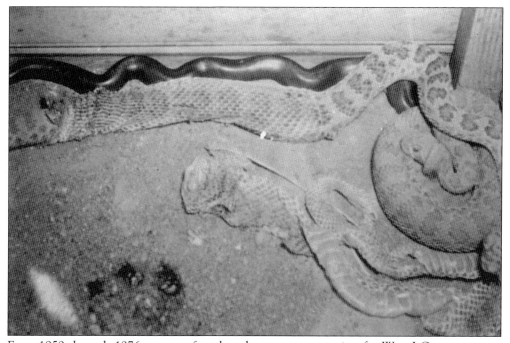

From 1959 through 1976, a cage of rattlesnakes was an attraction for Wan-I-Gan customers. Here was a rattler shedding his skin to produce a new rattle. The dark snake was a two-headed boa, so-called because the head and tail were so similar in shape. Boa snakes were not poisonous, but they would constrict around the arm of anyone friendly to them.

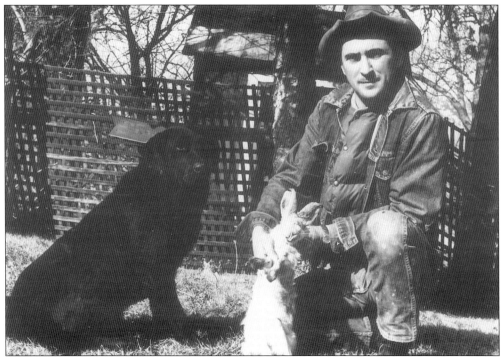

On September 20, 1971, Chico Horvath came by the Wan-I-Gan to show off the rabbit Hud had caught. Chico knew that Bill would be able to preserve a view of the tusks that were causing the rabbit to starve to death.

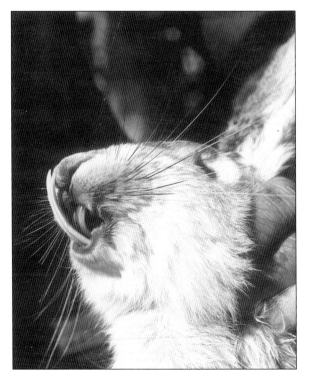

See those tusks!

A November 1954 slide from a hillside half a mile south of Wan-I-Gan not only covered the road, but also slid the road away under it, as the highway department later learned. New pavement was put right over this misplaced material. Florence Stands, going home from her teaching job in Emigrant, saw it start right in front of her. She turned around to alert us, so I saw it from a half-mile away.

The Whithorn children grew up at Wan-I-Gan. Bruce was six years old, and Duane was nine months old when we moved there. This picture was taken during Christmas of 1960. Bruce and Carol were in college. Alta was a junior at Park High in Livingston. Duane was attending school 1.5 miles down the road, where the old Six Mile School house had been moved to serve Chico students. Both boys have since died, and both have been granted their choice of being buried in the shadow of Emigrant Peak.

Wan-I-Gan was full of supplies. The cards of fishing lures hung from wires across the room overhead. Note the shelf-extender above Bill's head in this picture.

In the 28 years we Whithorns served the public at Wan-I-Gan, our store was not closed a single day. We traveled a lot, Bill worked seasonally in Yellowstone Park for 15 years, and we participated in community affairs, but we had wonderful help. Benna Busby was a faithful helper for 17 years. After we left Wan-I-Gan, she worked at Chico Hot Springs for about the same length of time.

The living quarters were right behind the store. Here our granddaughters Bonnie and Lisa were enjoying a ride on Dino, an unusual purple creature that was made from a cottonwood log by their dad, Jim Stands. We had more room for Dino than they did at their house in 1964.

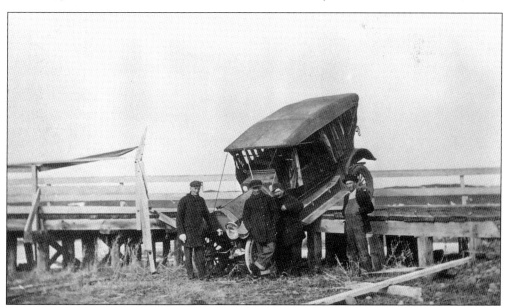

While the regular driver, Ross Williams, was away to bring back another car for Chico Hot Springs from the factory, Manley Fountain was driving this six-cylinder Luverne. He said something went wrong with the steering mechanism. Emil Hoglund, Alfred Dailey, and Joe Stands came from Emigrant to see the wreck.

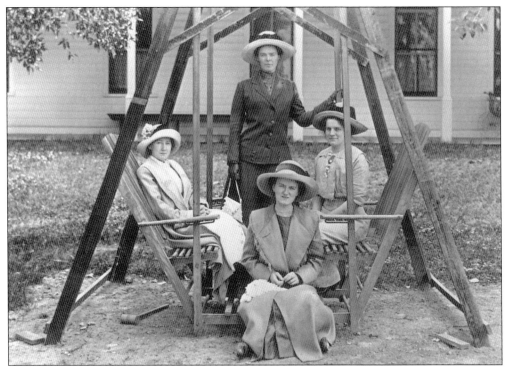

People have always enjoyed the relaxed atmosphere at Chico, as they do here in 1917. Standing is Mrs. Bill Bicket. The others are unknown.

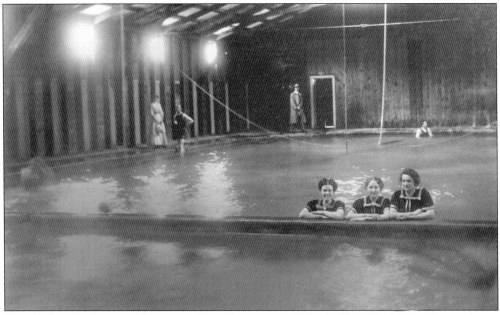

The pool in the foreground contained very hot water where people soaked away their arthritic pains. The large pool was cooled for swimming. Dressing rooms were at the back of the pool room. There was a covered walkway from the hotel to the swimming pool. Mrs. Bill Bicket is to the left of these bathing beauties.

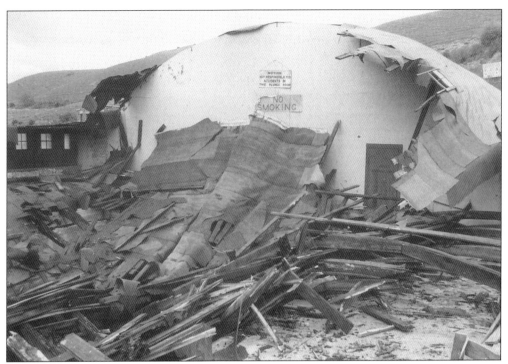

On May 30, 1957, the roof caved in on the holiday crowd in the swimming pool at Chico. Miraculously, no one was hurt, for a woman who saw it start gave a horrible scream of warning. Neighbors and workmen cleared the rubble to get the pool in order at once.

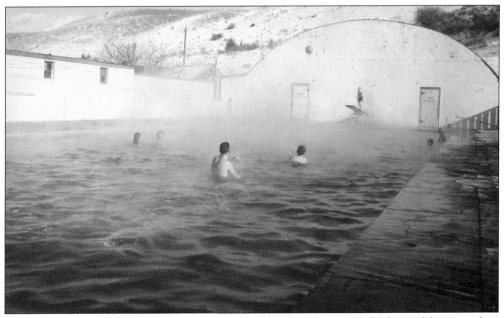

Since that time, the pool was been open to the blue sky above and the beautiful surrounding mountains. The hot pool has a cover.

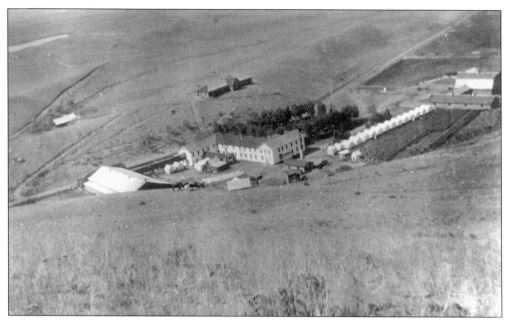

Chico had this appearance after the addition of a wing for doctors' offices in 1914–1915. The offices are marked by two dormers. The dark buildings on the hill are the dance hall and saloon, for Percie Knowles would allow no spirits on the hotel premises. Note the large garden behind the tents.

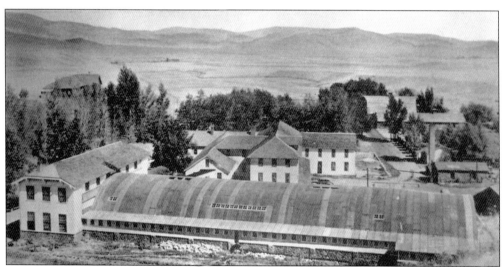

In 1939, Chico Hot Springs Resort and Hospital looked like this. The pool was covered with a roof set on laminated beams. Cabins added extra lodging space for guests. The steam from the pools permeated the wood, and the beams needed replacing every seven or eight years.

In 1964, Montana's Territorial Centennial year, the Emigrant Royal Neighbor Lodge hosted the District Convention. Several functions were held at Chico. Here are Agnes Putzker, Olive Kauffman, and Hattie Lambert in appropriate dress. The skirts are fashioned from white bed sheets.

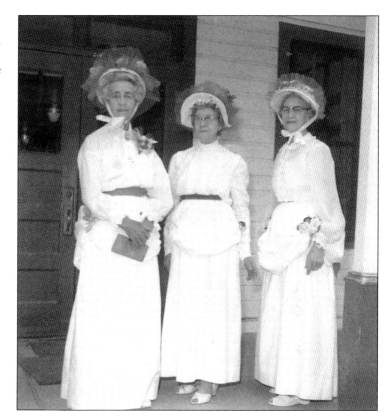

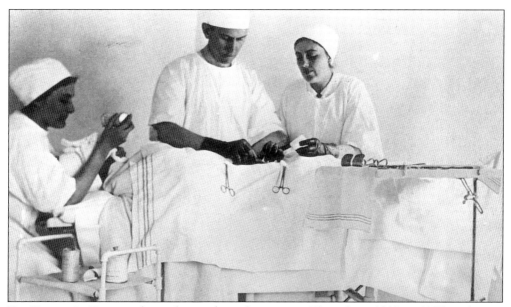

Dr. George A. Townsend was the resident physician at Chico from 1912 to 1925, and again from 1940 to 1949. When he saw this picture of himself operating during his early residency there, he was horrified. "I can't believe it," he said, "Short sleeves, no masks, and the nurse right over the ether." Dr. Townsend performed two remarkably successful brain operations at Chico.

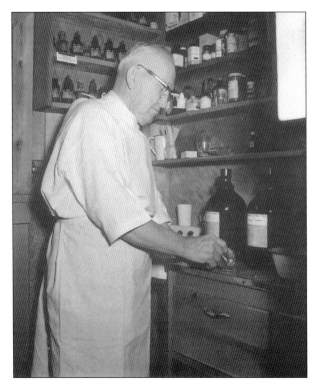

Doc always mixed his own medicines, dispensing them by the gallon and the barrel, his patients always said. In 1961, when this picture was taken, he was working in the office he had converted from his garage. He visited patients at Wan-I-Gan, where I boarded and roomed many. He spent his last winters at a home they had in Sun City, Arizona.

Doc's last operation was on himself, for the removal of a cyst from his finger. He and Huldah ("Nordie") were glad to have daughter Wanda Harwood join them for the community celebration of their 45th wedding anniversary on September 24, 1966. He died three months later.

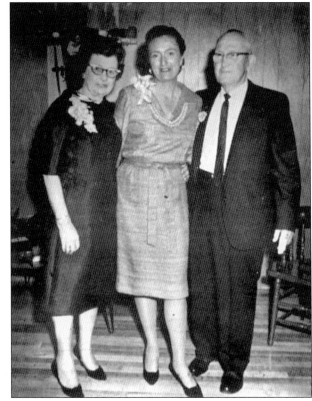

Mike Art, present owner of Chico Hot Springs (with wife Eve), was ready for the parade in Livingston on July 2, 1991.

Jack Conlin, whose children found many arrowheads at a buffalo jump near their home, fashioned them into pictures for his family. He left his name on Conlin Gulch north of Chico Springs. It was there that Conlin once had a sawmill.

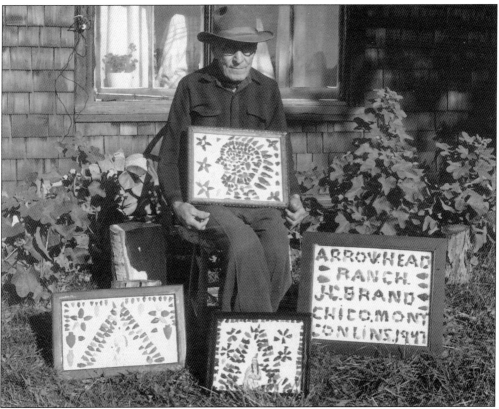

Fresh snow makes the rocks of tepee rings quite visible. This is near the dredge rocks of Emigrant Gulch. Native Americans, I am told, made tepees of two layers. The outside layer was about 2 feet short of the ground, while the inside layer was held down with rocks. The wind would be drawn up between the two layers of canvas or skins and draw the smoke from the fire inside the tepee. When they moved, they took their tepees. The rocks stayed in place.

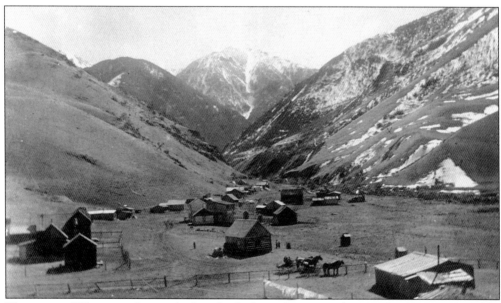

The name of Chico was first applied to this little settlement at the mouth of Emigrant Gulch. The schoolhouse here in the center of the picture was built in 1877, and enlarged as seen here in 1908. It was wired for electricity in 1948, and stuccoed in 1949. When abandoned in 1955, it was believed to have been the oldest schoolhouse in continuous use in the state.

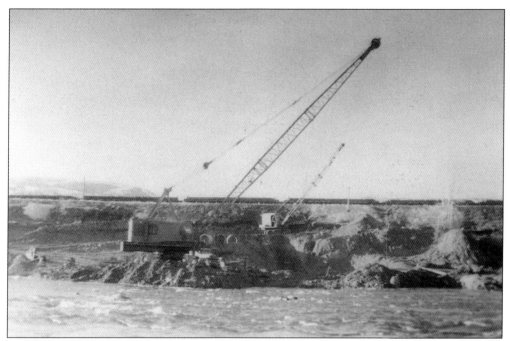

In 1957, construction of a 525-foot siphon under the Yellowstone River brought water from the west-side Park Branch Canal to the east side of the Yellowstone River. Thus was an additional 3,000 acres irrigated in Paradise Valley. In 1960, a section of Highway 89 was built over the siphon (MM 33.9E).

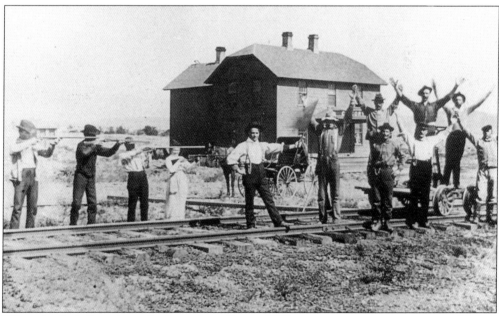

When the Park Branch was built up the valley in 1883, maintenance stations were established at 10-mile intervals above Tie Spur. This was the Chicory House. A real effort was made by Allen Bros. Realtors to sell lots and build a town here in 1883, but nothing developed. Here, the railroad crew was having fun (MM 33.9W).

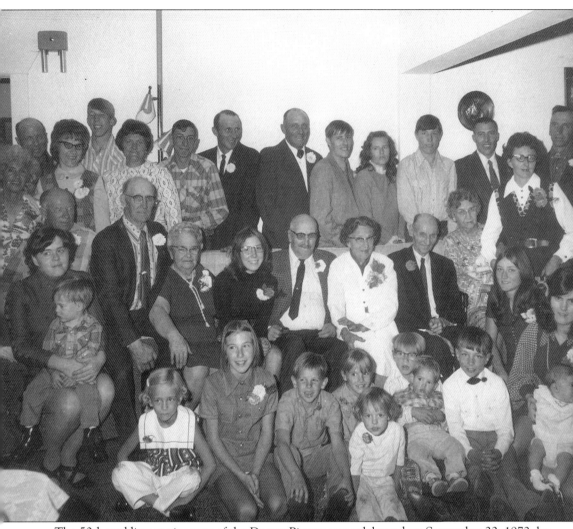

The 50th wedding anniversary of the Dorsey Pierces was celebrated on September 22, 1972, by a gathering of their family. Pictured, from left to right, are: (front row) Janet Pierce, Lori Pierce, Steve Juhnke, Tammy Juhnke, Pam Juhnke, Ted Pierce, Wayne Juhnke, Doug Pierce, Ann Pierce, and Jackie Pierce; (second row) Karen Pierce, John Pierce, and Kathleen Pierce; (middle row, seated) Oscar Hagberg, Ross and Gertie Pierce, Pam Pierce, Dorsey and Mae Pierce, Eldon Pierce, and Lilly Pierce McElvain; (back row, standing) Vi and John Pierce, Gloria Pierce, Bill Pierce, ElDonna Pierce, Gordon Rigler, Alvin Pierce, Charles Pierce, Bobby Pierce, Dorothy Pierce Juhnke, Alvin Pierce, D.J. Pierce, Rose Pierce Rigler, and David Rigler.

On August 13, 1962, Doug, the son of Charlie and ElDonna Pierce, was born with two teeth. They were his baby teeth, and he retained them until his permanent teeth were ready to come in. I sent the picture Bill took of him to a photo service. A few months later, it came back to us from friends in Pennsylvania in a newspaper story.

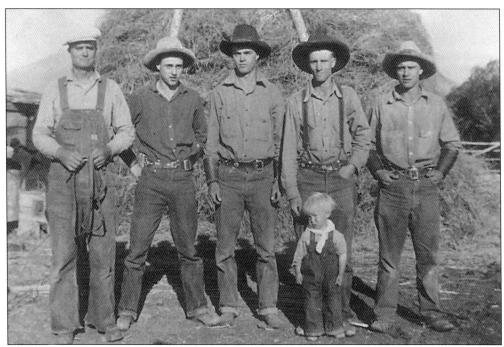

The Busby family was putting up hay for the Roups below Emigrant with a hay fork in this photo. From left to right, they are: father Sid, and sons Alva, Vernon, Ernie, and Harold. Willard was too young, and Bucky had not yet been added to the six-son total.

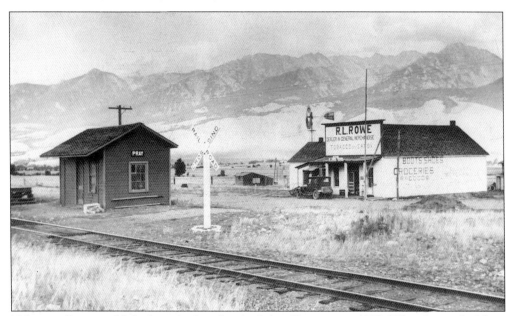

Valentine Egger established a rail siding 5 miles below Emigrant in 1907. When he applied for a post office in 1909, he asked for "Egger," but was refused because of its similarity to Edgar, Montana. He chose Pray to honor Charles Pray, Montana's U.S. Representative who established many small Montana post offices. In 1940, when Carl Weymiller was postmaster, he moved everything to Highway 89. The old Pray track is a landing strip of Planes and Reins (MM 36.9W).

Five

PROMINENT CREEKS OF PARADISE VALLEY
MILE MARKER 37 THROUGH 45

*All this is in Paradise Valley
In the Rocky Mountain West
Where you look up toward the mountains—
Mountains east and mountains west.*

*A stranger could come to our valley
Seeking someone he knew long ago;
You'd send him, not into the streets,
But "Up Barney Creek," you know.*

*It could be on Miner or Big,
Dry, Strickland or Pine.
You might direct him to Sixmile,
Or Eight, but we have no Nine.*

*On highways you see the creeks named;
You may have considered that queer,
But our valley is full of creeks—
They're the maps we know around here.*

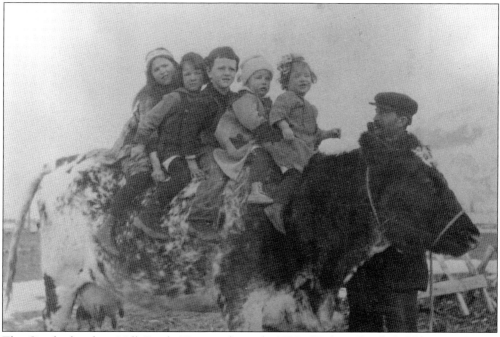

The Goudys lived on Mill Creek. Here in the early 1920s, Herbert Goudy held his cow Beauty while little cousins had a ride. They are, from front to back: Minnie Alberta Goudy, Alvina Beck, Victor Beck, Freda Marie Goudy, and Ethel Mae Goudy (Mill Creek Turn-off, right MM 37.2).

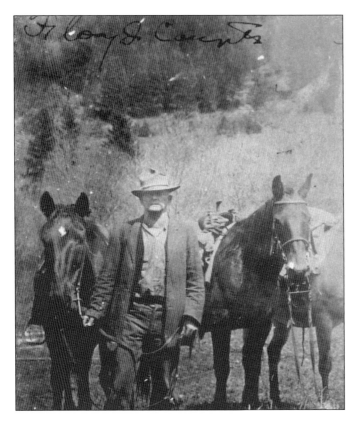

In early days, miners working in Emigrant Gulch crossed over into the Mill Creek drainage. Floyd Counts did that and homesteaded the ranch later owned by Archie Allen. To it he packed in a mowing machine by way of a trail. He left his name on the map. Many Counts family members have mined.

Ralph Smith (at right), who lived up Mill Creek, was considered a hermit. He walked to Livingston infrequently for supplies. In this photo, he is visited at his mountain home by Mrs. Ernest Lyons, Fern Waynard, and Ernest Lyons.

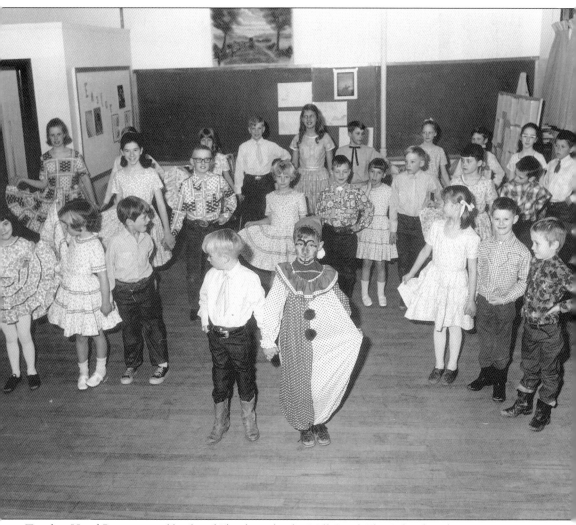

Teacher Hazel Peterson and husband Floyd taught the Mill Creek Flat School students to square dance. On May 5, 1970, they were dressed and ready for a performance. The students pictured, from left to right, are as follows: (front row) Sonya Neal, Bonnie Stands, Gordon Alderson, Nelson Story, Cricket Alderson, Lorna Marchington, Mark Drye, and Larry Blakeslee; (second row) Debbie Drye, Chuck Taliferro, Lisa Stands, Doug Pierce, Shelly Neal, and Duane Clark; (third row) Libby Taliferro, Charlie Blakeslee, Cindy Fredericks, Robert Story, Tammy Fredericks, Nickie Peterson, Tana Peterson, Mike Story, Debbie Blakeslee, Ben Cunningham, Rhonda Drye, and Billie Fredericks.

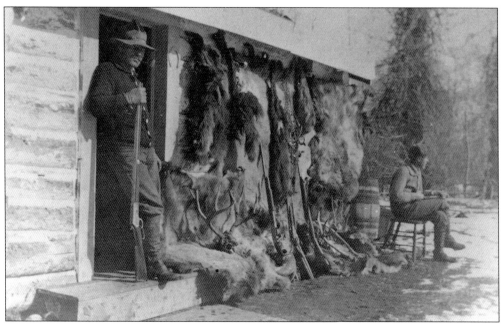

This is the cabin at the old Sells Place on Mill Creek. George Bonnell (left) and Wally Egger show what good hunting country the area was. This place was later the home of the Jack Waynards. One of the Sells daughters drowned in the mill race there. Mr. Sells sold farm equipment for A.W. Miles Co.

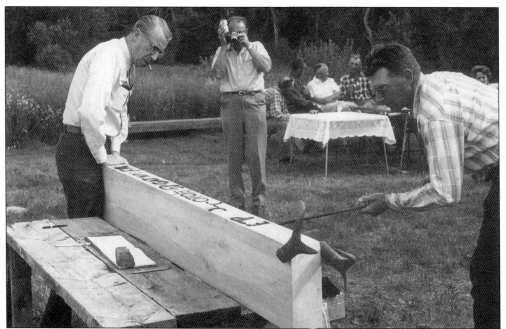

On July 16, 1967, Mr. and Mrs. Otto Brown and Mr. and Mrs. George Lefgren were hosts at a Sunday afternoon buffet dinner at the Brown home on Mill Creek. By request, the guests brought their branding irons and left their branded imprints on the mantle for the fireplace in the Browns' casual room. Here is Jack Vink putting his iron to the wood.

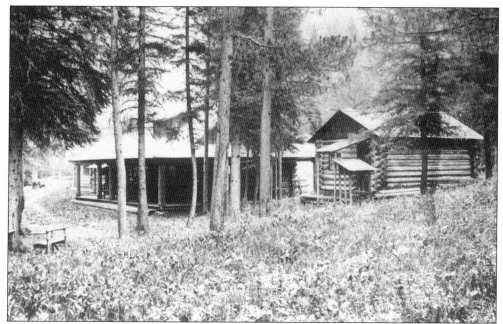

Walter and J.D. Matheson, who had an interest in Emigrant Hot Springs (Chico), bought the mineral springs on Mill Creek in March of 1884. They felt that the water there resembled that of Apollinairis Springs in Yellowstone Park. They did not develop Montanapolis Springs on Mill Creek, however. This shows the later lodge built at Montanapolis.

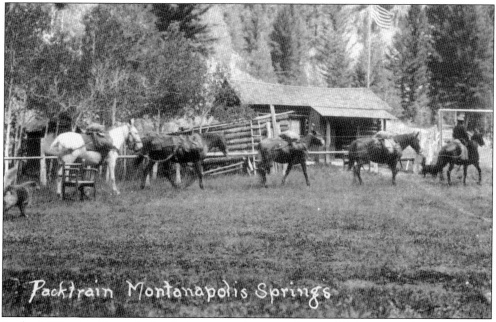

In the 1930s, Joe Simon had a little store and some cabins at Montanapolis Springs. Johnie Hankins, packer for Harvats sheep camps on Mill Creek, often packed out from Montanapolis Springs. Here is Johnie packing out to sheep camp with 200 pounds of salt on each horse.

This shows the inside of the Diamond S Lodge that C.L. Smith built at Montanapolis Springs in the early 1930s. He built cabins to accommodate guests, too. About five years later, after he sold out, he went to the Boulder country and built a lodge by the same name.

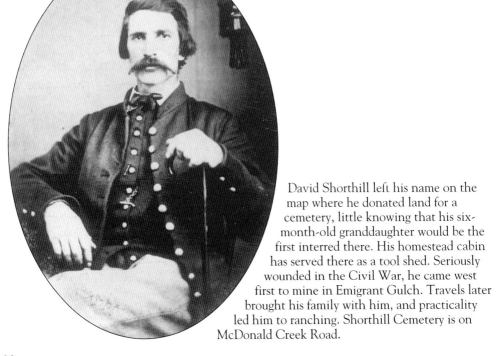

David Shorthill left his name on the map where he donated land for a cemetery, little knowing that his six-month-old granddaughter would be the first interred there. His homestead cabin has served there as a tool shed. Seriously wounded in the Civil War, he came west first to mine in Emigrant Gulch. Travels later brought his family with him, and practicality led him to ranching. Shorthill Cemetery is on McDonald Creek Road.

Joe George came to Montana from New Mexico driving one of the wagons of the David Shorthill family. He married their daughter Eleanor and took a homestead next to theirs. Though he moved to California in 1944, he left his name on George Lake and George Creek. He was no relative of Yankee Jim George.

On June 25, 2000, Pine Creek United Methodist Church celebrated its 100th birthday. This is the same building (with additions) that was dedicated on February 11, 1900 (turn-off to Pine Creek; MM 43.3; right on East River Road).

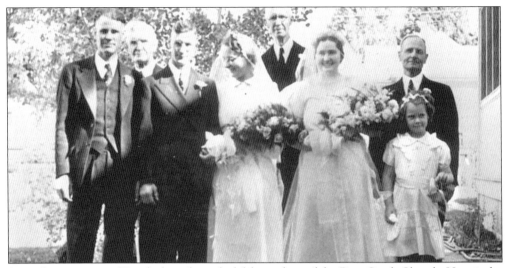

Several generations of Smiths have been faithful members of the Pine Creek Church. Here is the wedding party of Arthur Smith and Olive Bartlett on October 2, 1938. There were three ministers officiating, and three others as guests. Shown here, from left to right, are: Foster Smith, Edward Smith, Arthur Smith, Olive Smith, Robert Smith, Amy Stevens, and Edward and Clara Bartlett.

The last resident minister to serve Pine Creek Church was the Reverend Edwin Dover, who served from 1964 through 1970. Here is his family in 1966. They are, from left to right, as follows: (front row) Denice Dover, David Dover, Carrie Dover, Doug Dover, Bob Lind, Leslie Dover, and Lorrie Dover; (middle row) Mildred Dover, Rev. Dover, Kathy Lind, LeRoy Dover, and Louella Dover; (back row) Carwin Dover, Janice Lind, Robert E. Lind, and Lewin Dover. This photograph was taken on December 26, 1966.

On April 10, 1958, Howard Crane was honored at Pine Creek Hall for being a Paradise Experimenters' 4-H leader for 20 years. Here are some of his 4-H'ers attending. Pictured, from left to right, are: (seated) Virginia and Jerry O'Hair, Collin Fallat, and Howard, Lois, and Dean Crane; (standing) Don Nell, Russell Lyons, Milton Rogers, Richie Pirtz, Clinton Rogers, John Melin, and Don Herne.

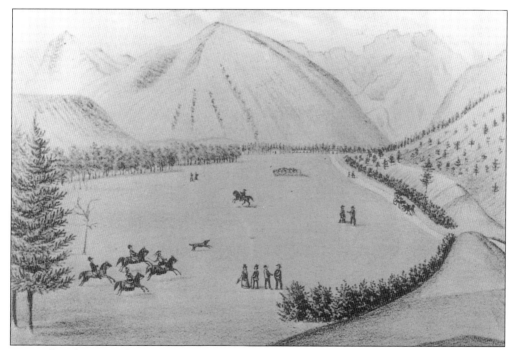

Grinnell Park was used as a recreation site as early as the 1880s. This was named for George Bird Grinnell, who wrote of the beauties to be found in western Montana, particularly those that became Glacier Park. In 1923, this area of Pine Creek became a Methodist Church Camp and was renamed Luccock Park. The Pine Creek recreation area is directly behind this park.

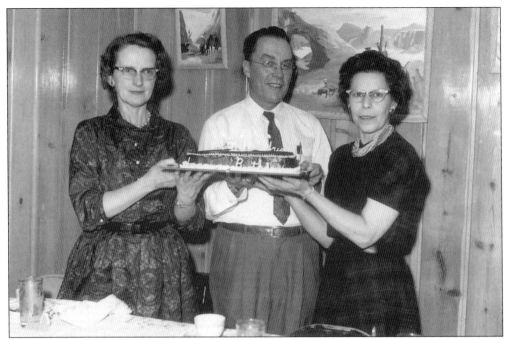

For many years, the Smith and Whithorn families celebrated Olive's and Bill's birthdays together. Then it was learned that Doris Allen shared the same January 5, 1911 day of birth. So these three of Paradise Valley had birthdays together for several years. Pictured in this photo, from left to right, are: Olive Smith, Bill Whithorn, and Doris Allen.

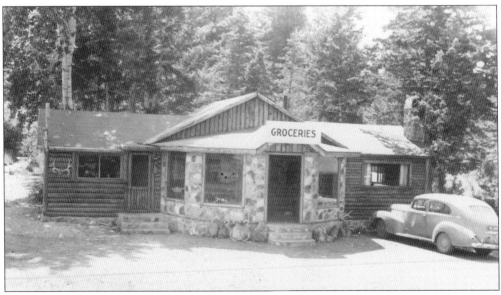

In 1946, Wayne and Pauline Crosby built a store and living quarters at Pine Creek. Several cabins and a coffee shop were later added to accommodate tourists and fishermen. Wayne did the stone work. Pauline was the daughter of Rev. and Mrs. Ben Davis. Reverend Davis served the Pine Creek Church from 1940 through 1953.

This photo shows the home of Ward and Ruth (Fowler) Durgan, who were married in 1916. Ruth was an accomplished musician and singer. She and Marion Melin sang many duets. They were much in demand to sing at weddings and funerals. The Pine Creek School in the background was built in 1904, and has received several additions, in 1923, 1978, and 2000.

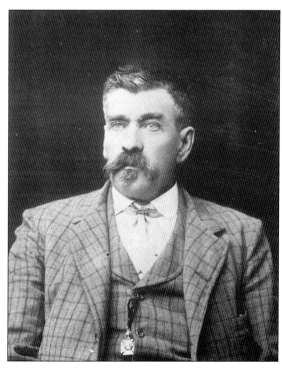

Returning to the west side of the Yellowstone, we shall investigate some of the history of that and the Trail Creek area. Ben Strickland came to Montana over the Bozeman Trail in 1864. He mined in Emigrant Gulch and furnished meat for the miners for ten years before taking a homestead on Strickland Creek. He gained a favorable reputation as a mediator in trouble that developed between local Indian tribes and white settlers (Trail Creek turn-off at MM 44.4).

John Malcolm Darroch came to Hayden and moved into the post office building in 1892. He became interested in sheep, once owning as many as 3,400. The creek near Jardine, which carries his name, marks the area where he had a sheep permit for ten years around 1900. He was a state senator from Park County, and though he served only one term, his manner and appearance were such that he was always called "Senator."

Richland was District #2 in Park County, and only two years ago lost its status when it was combined with Arrowhead (Mill Creek Flat). In 1896, a frame building replaced a log building constructed in 1880. A second room was added in 1953. In 1960, the work shown here was the addition of a third room. Tom Durgan and Homer Douglas were on the ladders, and Bob Weimer was looking on. The building is now vacant.

104

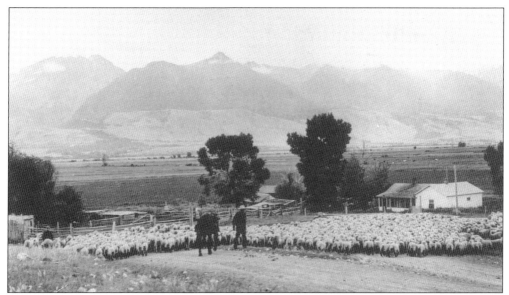

Norris Spangler had just come over Ballinger Hill with a band of Harvat's sheep, headed for either Rock Creek or Mill Creek, when this photo was taken. This ranchstead was the home of the M.S. Ballingers from 1880 until 1905. In 1937, it belonged to Paul Wright. A short distance south of this is the turn-off to Trail Creek.

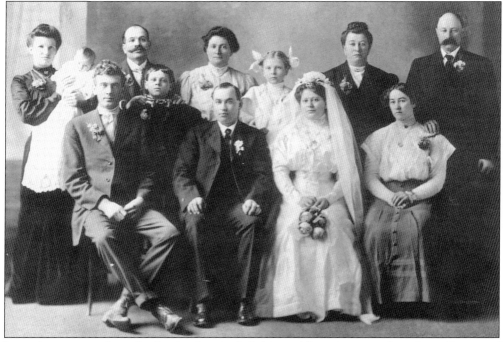

It was important to have family members included in wedding pictures such as this in January of 1910. Seated beside the newlyweds, Mr. and Mrs. Gabriel Smerke, are the attendants, Horace Stebbins, and Daisy Smerke Stebbins. The woman with a child is unidentified. Others pictured, from left to right, are: Mr. and Mrs. Louis Mesoyedz, Tony and Rosie, and Mr. and Mrs. Martin Smerke. The bride (Helen Mesoyedz) died in 1922, leaving two sons: Martin, 11, and Ed, 7.

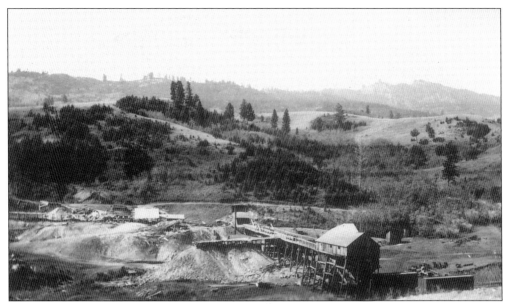

Trail Creek, west from the Ballinger place, had several productive coal mines. The Maxey Mine, shown here in 1908 by the U.S. Geological Survey, was in production longer than most. Even into the 1950s, local people could buy coal at Maxey's.

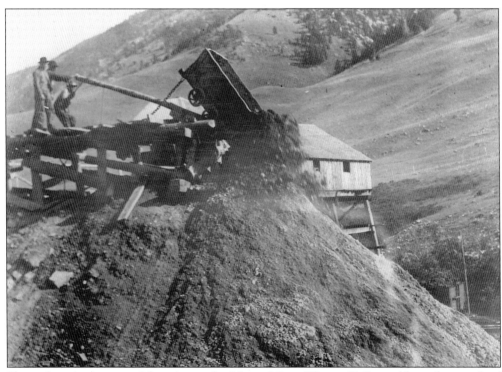

Shown here is one way of dumping at the Maxey Mine. Warren DePuy told me that much of the slack here was hauled to the mill at Trident during World War II because they could not get coal to run the cement plant there.

The Maxeys were always active in community affairs. Eva Maxey Garnier managed the children's parade during the 1920s and '30s. As a part of that parade, Nelle Jean Maxey practiced faithfully, and for several years rode the whole parade route standing on a horse. Her father, Dave Maxey, always led the horse. This was the drayman's horse. Dave had given it a bath, and the drayman did not realize it was his horse in the parade.

The Romes, who came from Norway, took up a homestead on Trail Creek in a draw across the road from the Maxey Mines. There they built the two-story log house shown here with Grandma Rome. Later, they sold out and moved to Deep Creek on the east side of the Yellowstone. Some of the family still live in Livingston.

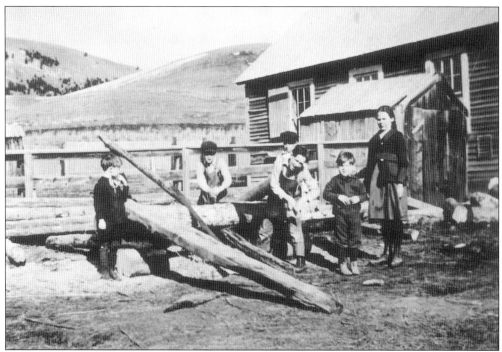

At the Trail Creek School, recess activity for the older boys included sawing wood for the schoolhouse stove. Tom and Dave Strange are shown manning the crosscut saw. Others in the picture are Elmer Coscik, Fay Rose, and the young Maryott boys, sons of the teacher.

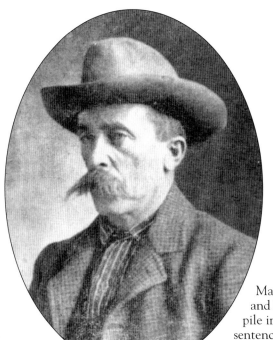

Martin Zidmair, who killed George Reider and buried his body in a burning sawdust pile in 1901, was found guilty in 1903. He was sentenced to be hanged on September 4, but he cheated the gallows. He had been able to hide a harness strap in his cell. With it he hung himself.

Six

THE END OF
PARADISE VALLEY
MILE MARKER 46 THROUGH 54

Here another canyon squeezes the Yellowstone River as it snakes its way to the great bend. It was at this bend that Livingston came into being. At this bend, the Yellowstone River is sent to lower elevations. This became the route of early travelers on the Yellowstone. First there was William Clark, with 18 men of the Corps of Discovery and the Charbonneau family in 1806. Then came those who followed the Bozeman Trail to the gold fields of what became Montana in 1864–1868. Next came the Northern Pacific Railroad in 1882–1883, making its headquarters here for the shops and for travel to Yellowstone National Park. When cars came to be the favored means of transportation, the Yellowstone Trail developed. It was followed by Highway 10 and then Interstate 90. So, welcome to Livingston, Montana, end of Paradise Valley on the Yellowstone.

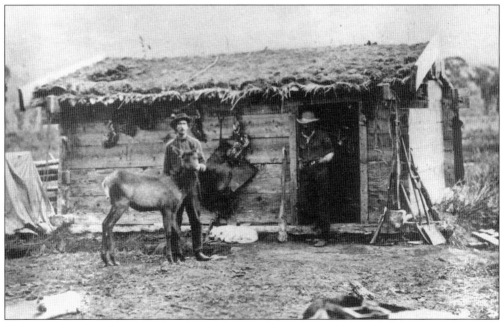

The Major Pease cabin was located at the head of the big spring south of Livingston. F.S. Pease served as head of the Crow Indian Agency at Fort Parker from 1870 to 1873, when he came to ranch here. This cabin was built of wide, thick boards cut with a whip saw. In 1883, Pease sold to General James S. Brisbin, for whom the railroad maintenance station was named (MM 47.2).

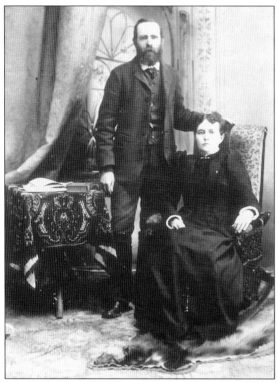

Owen T. Armstrong and his wife came to the valley in 1878 by covered wagon after the loss of a wheat crop by flood the previous year in Missouri. The trip took three months with two wagons and six mules. In 1901, they bought the ranch with the big spring on it. The efforts of Armstrong and John M. Darroch were responsible for the Armstrong Ditch, now called the Park Canal. Armstrong left his name on the spring and the ditch (MM 47.2).

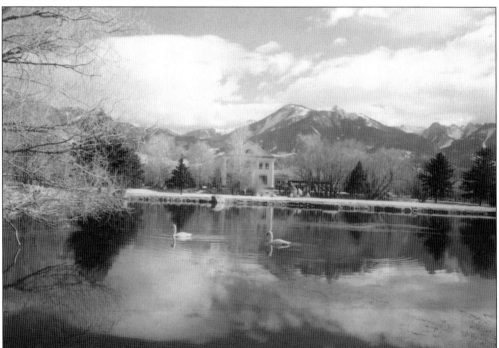

Warren DePuy had this southern mansion built from a picture he had admired for 30 years. It was started in 1966. The present ponds and streams are fish-for-pay areas. Members of his family still live here. His daughter, Betty, occupies her time with sheep. Daughter Cheryl is an artist (MM 48).

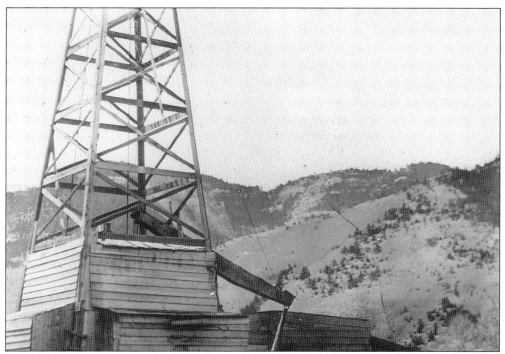

When Sam Holiday owned the DePuy ranch, this drill frame was over a dry well. But the area produced another necessary commodity—lime. At MM 51, you can see the best-preserved lime kiln, a necessity for the three brick manufacturing plants in Livingston. Nine two-story brick buildings and the railroad shops required many bricks in 1883.

Billy Billman had a cabin on a stream that flows into the Yellowstone River from the west. Billman Creek is named for him. It was the stream followed from what became the Bozeman Pass by William Clark of the Corps of Discovery. They rested here from 2:00 to 5:00 p.m. on July 15, 1806.

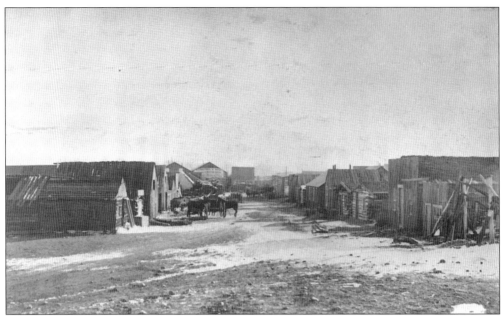

The first town at the great bend of the Yellowstone was Clark City, where merchandise for railroad builders first arrived. Unknown to residents there, railroad officials had purchased land farther north and decreed that the tracks should be placed there, where they could reap a handsome profit. Clark Street was named for the abandoned Clark City. Post offices established there were Clark City, on October 17, 1882, and Livingston, on November 13, 1882.

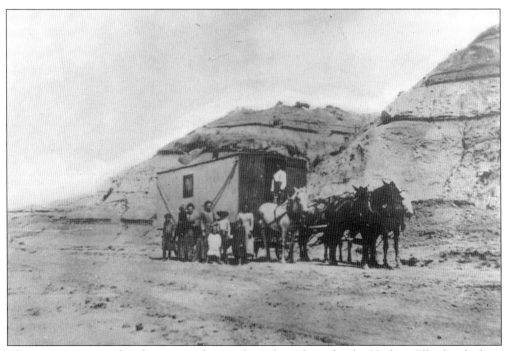

This wagon, equipped with a screen door and windows, brought the Herbert Ellis family from Iowa to Livingston in 1901. This picture was taken near Napoleon, North Dakota.

Having no place to live, the Ellis family set their wagon down in the 400 block of South Eighth and lived in it. The house has been added on to, but the wagon is still inside.

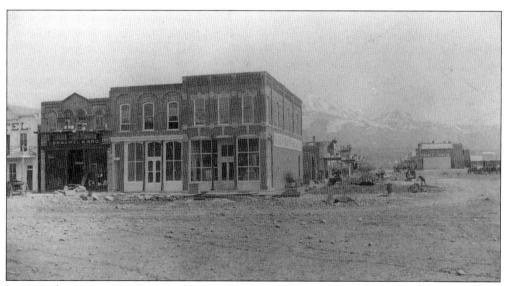

In 1883, the George H. Carver building at the corner of Park and Main was not yet occupied. He had bought the lot while in business in Clark City, but did not build right away. I. Orschel and Bro. built in an "L" around Carver. Billy Mitchell's Merchant Hotel was so close to Orschels' that he moved it about 6 feet away to allow light and air to get into his hotel rooms.

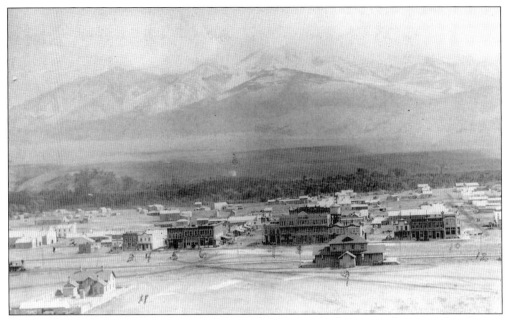

This was Livingston about 1886. In this photo, the area marked #1 was a skating rink; #2 was a furniture factory; and #9 was the depot which had been moved to that location between Main and Second Streets from where it had originally been even with Third Street. This depot burned in August of 1888. It was rebuilt immediately.

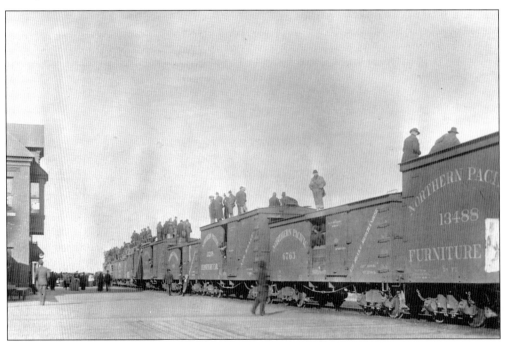

Here is Coxey's Army on the way to Washington D.C. to demand jobs in 1894. Livingston played an important part in the great American Railway Strike, because it was an important division point of the Northern Pacific. The first train was held up here on June 27. For 13 days, no train passed through town. It was July 11 when the strike was called off.

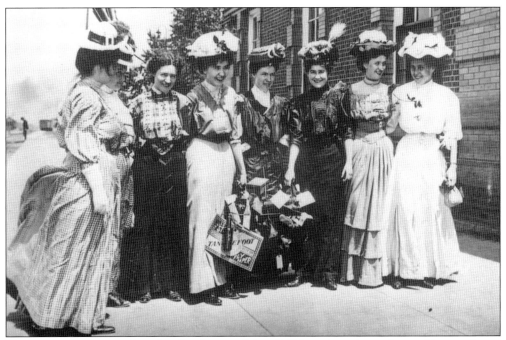

These young women gathered at the depot in July of 1907, with packages donated by merchants of Livingston as gifts for the Ray Clark-Anna Heffner wedding. Pictured, from left to right, are: Mary Murphy, Irene Locke, Birdie Clark, Gladys Potter, Neet Locke, Etta Hruza, Delores Mahon, and Alberta Goughner.

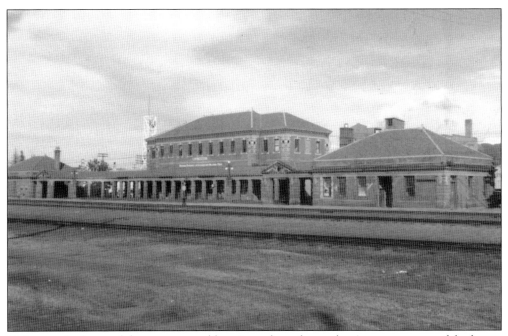

Livingston had several depots at several locations along the tracks. Announcement of the last to be built came in November of 1901. It was dedicated on May 30, 1902. Passenger train service stopped on October 29, 1979. The depot building is now one of four museums in the town.

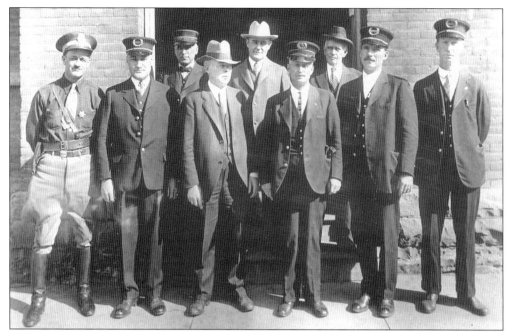

These were police and city officials around 1927. Pictured, from left to right, are as follows: (front row) Martin Zollman, William O'Hern, David Fitzgerald, Peter Holt, Wendell Murphy, and Ben Barr; (back row) Charles Cartnal, Pat Kelley, and Judge Ragland. Zollman and Holt were killed in the police station by Rollin Davisson on August 21, 1929. Read all about it in the papers!

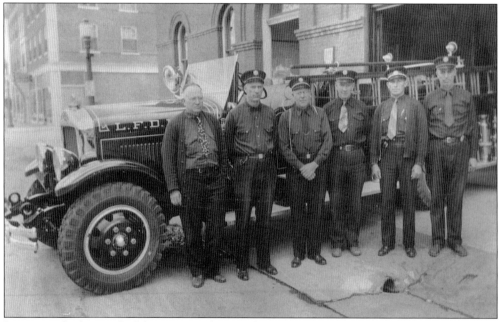

Livingston had many bad fires very early in its history. In 1969 alone, four destructive blazes cursed the city. Here is the fire department in 1936. Pictured, from left to right, are: Jack Van Heining, Chief; Clyde Neal, Assistant Chief; Ralph Sherwood; Homer Terwilliger; Harvey Cole; and Sam Jones.

116

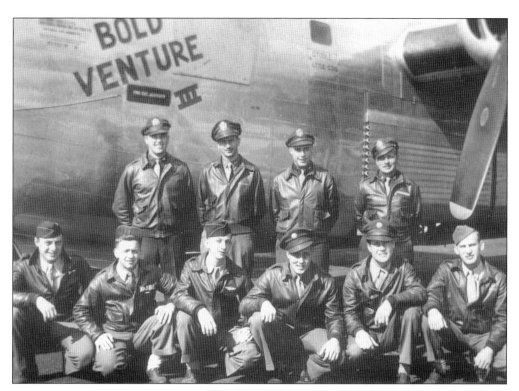

Don Fraser (at far right in the back row) served with the heavy bomb group shown here near Kings Lynn, England. After five missions, the group was deactivated because of heavy losses. Of 64 men sent out, only 12 returned. Don served as bombardier, though training in four southern states had prepared each for any position on B-29s, which as yet were not ready for service in World War II.

This taxicab was parked at Lewis and B Streets with owner-operator Wally Walker sitting on the running board. In 1917, it was said that the cab needed to be pushed to start. The women pictured are Mrs. William Oakley (left) and Margaret Roup.

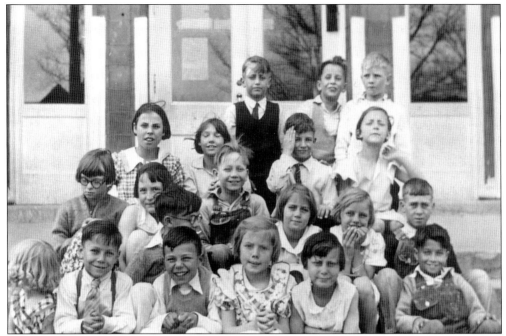

May Martin was the teacher of this second grade class in the North Side School in 1933. The children pictured, from left to right, are as follows: (front row) (?) Martin (teacher's daughter), Kenneth Hubbard, Bob Fior, Pat Watson, Irene Merritt, and Emil Ricci.; (second row) Margaret Commings, Betty Jo Loeffler, Dale Speak, Katherine Kutchler, Pat Kelly, and Frank Armentaro; (back tow) Earl Brown, Larry Taylor, and Bob Compton.

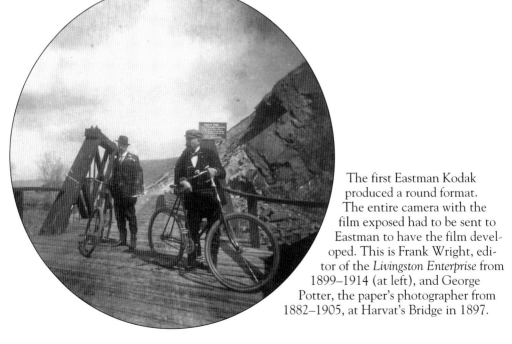

The first Eastman Kodak produced a round format. The entire camera with the film exposed had to be sent to Eastman to have the film developed. This is Frank Wright, editor of the *Livingston Enterprise* from 1899–1914 (at left), and George Potter, the paper's photographer from 1882–1905, at Harvat's Bridge in 1897.

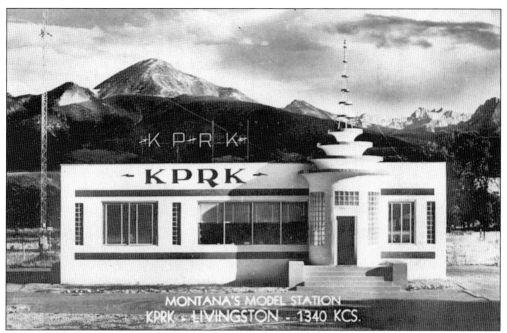

Paul McAdam's KPRK signed on the air on January 8, 1947. Two weeks later, Jack Hinman went to work at the station, and in 1963 the Hinmans bought the facilities. McAdam also organized the cable TV facilities for Livingston. The station is now owned by Marathon Media.

Mrs. Robert Alton was the wife of Livingston's first doctor. She was president of the Yellowstone Club in 1902. First established in 1892, this club, which is still active, established a free public library in 1901, and worked toward the construction of the present Carnegie Library in 1904.

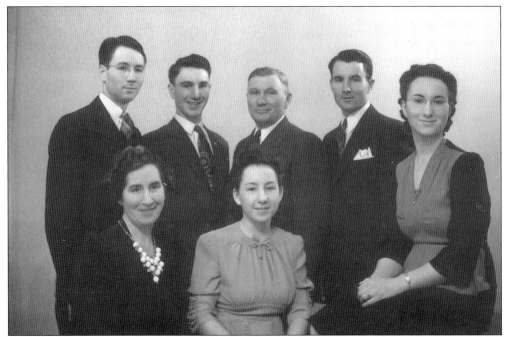

This is the H.E. McGee family in December of 1941. In the front row are Mother Mildred and Lorraine. In the back, from left to right, are: Harold, Wallace, Father Howard, Warren, and Louise. The father retired as an engineer in June of 1958 after 53 years of service with the Northern Pacific Railway. Warren served 40 years as brakeman and conductor. He is a railroad historian extraordinaire. Harold had a photographic studio in Livingston from 1939–1958.

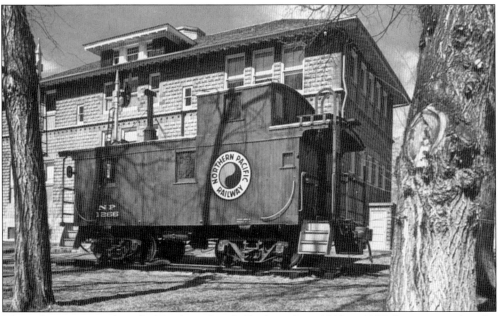

This caboose was used on the Northern Pacific Railway from 1889 to 1970. It was moved to the Park County Museum (now called Yellowstone Gateway Museum) on February 28, 1977, and set on trucks already on the tracks by three end-loaders of Park County.

This is the Vince VanAken family in 1963. Pictured, from left to right, are: Richard, Vince, Altha, and John. Vince was largely responsible for refurbishing the inside of the caboose of the museum grounds. He worked as brakeman and conductor for the Northern Pacific for 31 years. He has served the Senior Citizens and Pioneer Society as president and as a director of the museum. His son Rick is following in his father's footsteps as a public servant.

Nurse Rae came to Livingston in 1892 to be a nurse in the Northern Pacific Hospital on C and Chinook Streets. Later she operated her own maternity hospital. Here she is with the Bicket sons, William Francis (born July 10, 1914) and Wallace (born July 16, 1917). The picture was taken on September 16, 1917.

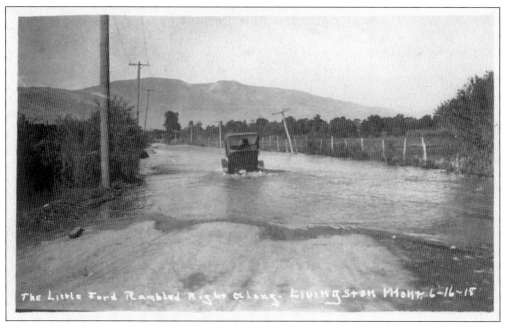

The Little Ford Rambled Right along. LIVINGSTON MONT 6-16-18

This little Ford was rambling along through water that covered the park road south of town. The highest water hit on June 16, 1918. Several bridges were washed out, including the $15,000 Harvat Bridge. It connected the eastern part of Park County to Livingston, but people afoot could make it into town by walking over the railroad bridge a mile below Harvat's. It was said that some brave souls would ride a horse over the 1911 steel railroad bridge.

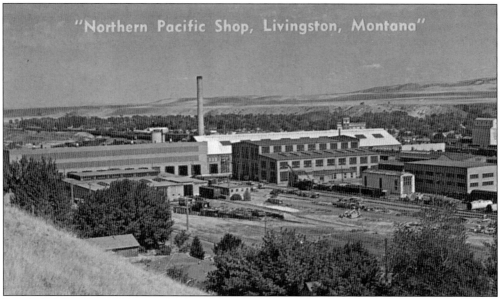

"Northern Pacific Shop, Livingston, Montana"

In 1883, $.5 million went into construction of N.P. machine and repair shops in Livingston, because it was nearly midway on the line. An addition was made in 1902. In 1944, conversion from steam to diesel was made. In February of 1986, the shops closed, and the machinery was moved out. Now Montana Rail Link (MRL) and Livingston Rebuild Center (LRC) do repairs and take care of freight traffic through Livingston.

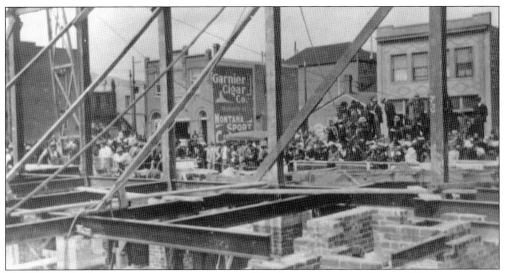

Looking through the framework construction of the Livingston post office in 1912, one sees the Garnier Cigar Company. One of three such businesses, it had ten employees in 1900, second only to the railroad workforce in town.

In 1900, William Hruza was owner of the Cold Storage Market in Livingston. For this business, he slaughtered 10,000 pounds of beef, 6,000 pounds of pork, and 3,000 pounds of mutton weekly, in addition to carrying veal, lamb, poultry, and fish. Note the buffalo meat for sale and the whole pigs under the displays. He invented the refrigerated display case seen at the back of the store.

The parade on July 5, 1897, merited seven full pages of news. Of the parade it was said "No grander nor more satisfactory observance of American Independence was seen in this section of Montana." July 4th was on a Sunday, hence the parade was on Monday, July 5. Here was General George Washington (Harry Hathhorn) on his white charger.

This was George Simon's Boston Store on Main Street in 1908. Pictured, from left to right, are employees Anna Morrison (Graham), Ethel Smith (Jondrow), Chastina Commings (Newell), Bernice Wilson, George Simon, Bob Gentle, Otto Sievers, and an unknown salesman.

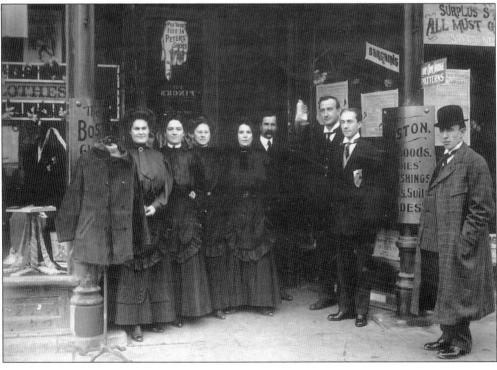

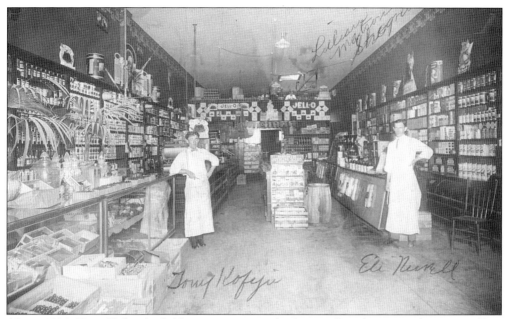

About 1914, Tony Kofeju (at left) was a partner with Eli Newell in the grocery business. Lillian Matson Shogren, the bookkeeper, can be seen upstairs in the office. There are electric lights in this store, and only one big barrel, indicative of changing times in the grocery business. Newell operated a store in the same location for 51 years.

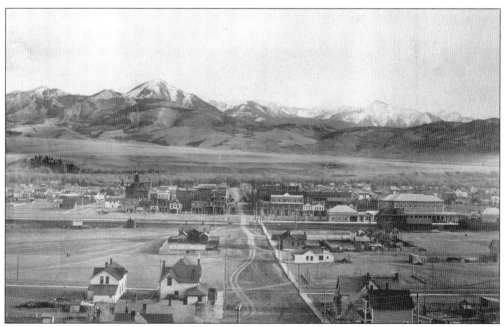

Livingston looked like this in 1903. There was as yet no underpass on Main Street, but the new depot had been built (in 1902). Sidewalks at the time were wooden. Lehrkind had not yet put up his building on Park and B Streets, but it looked as though his 1903 construction was ready to start. Note the tennis court on Chinook and Main, a corner once considered for the North Side School (now used as the Yellowstone Gateway Museum).

On July 8, 1942, 50 men put in an evening moving rocks on the north side hill to outline a mammoth fish. Chief of Police Frank Olson directed the operation. Painted white, it became an outstanding advertisement for the 1942 $1,000 Trout Derby. Tents, a Ferris wheel, and a gymnast's tower all indicate that a carnival was in Livingston at the time. To the left is cheap housing provided during the World War II years.

To the right of the fish is a "P," built in 1953 by Park High students directed by Don White, Fred Nesbitt, Bob Figgins, Bill Wanderson, and Ken Hanson. John Fryer said Fred Nesbitt and Ken Hanson had walkie-talkies, and Ken directed operation from Park Street. When Don White ran for President of Student Council, it is said that he closed his campaign speech with "I want a P on the hill." He won a lot of laughs and the election.

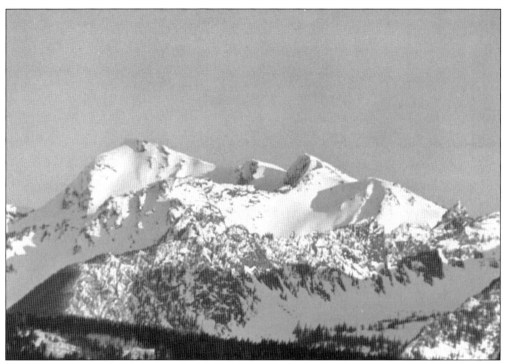

Photographer Ben Strickland caught the mountains south of Livingston just right to show the Sleeping Giant. When the picture is turned vertically, it makes a striking resemblance to Christ with a crown of thorns on his head.

Dr. Carver's Diving Horses at the Park County Fair pleased the crowd in 1916. On September 19, the horse, in diving 40 feet into the water tank, did not make a straight dive and both horse and rider had a hard tumble. Both recovered. Disney's movie *Wild Hearts Can't be Broken* is based on this act.

Something new has been added lately in Livingston. It is the workplace of Amber Jean, who works with wood. She takes after it initially with a chain saw or power tool to release a "first form." Quiet hours of hand carving follow to release the features she first had envisioned. She says "Many a night is spent creating piles of wood chips and sawdust."